# PROHIBITION
## IN
# ATLANTA

# PROHIBITION
## IN
# ATLANTA

### TEMPERANCE, TIGER KINGS & WHITE LIGHTNING

RON SMITH & MARY O. BOYLE

AMERICAN PALATE

Published by American Palate
A Division of The History Press
Charleston, SC  29403
www.historypress.net

Cover image courtesy of Georgia Archives, Vanishing Georgia Collection,
image number emn053.

First published 2015

Manufactured in the United States

ISBN 978.1.62619.606.3

Library of Congress Control Number: 2015936860

# CONTENTS

# ACKNOWLEDGEMENTS

Hours of sleuthing and digging into archives went into the creation of this book. However, this research would not have been accomplished without the aid of historians, research institutes, collectors and ardent supporters.

## RESEARCH INSTITUTES

We humbly rely on all the people who have built and maintain technology that allows millions of documents and materials to be viewed remotely. Our research would be limited without access to the Library of Congress, Fold3.com and the Georgia Archives. We extend sincerest thanks to the Cuba Family Archives of the William Breman Jewish Heritage Museum; the libraries of Emory University; the Kenan Research Center at the Atlanta History Center; Dr. Jeffrey Glover and Dr. Timothy Crimmins, Georgia State University (GSU); and the GSU Library Special Collections (especially Ellen Johnston).

## COLLECTORS, HISTORIANS AND SUPPORTERS

We appreciate photo access to and information from the Kimball House and Old Fourth Distillery. These businesses, based on old traditions, are introducing a new generation of Atlanta's residents to finely crafted cocktails and distilled spirits.

Special thanks to Rose Dunning for drawing custom artwork. Our appreciation goes to Matthew Tankersley and Josh Blackmon for creating an impressive custom map. As with *Atlanta Beer*, Sam Covell read our draft and gave thoughtful feedback that helped us improve the manuscript. Thanks to Ken Jones, Dr. Richard Funderburke, Andreas Platt, Bob Toney, Ken Evans, Butch Alley and Dona Patrick for providing images. We appreciate that Dwight Bearden took time to chat with us about moonshine. We offer heartfelt gratitude to family and friends for their encouragement as we worked on a second book. Finally, we are honored that The History Press accepted our proposal to write on this untidy topic of prohibition.

Cheers,
RON SMITH AND MARY BOYLE

# INTRODUCTION

The history of prohibition in Atlanta is different from that of the young flapper sipping her cocktail in a Manhattan speakeasy. She and her big-city companions would have found themselves in a foreign world in the South.

Reconstruction, race relations and the vain struggle of the social elite to maintain its position in society set the stage for a prolonged period of alcohol prohibition in Georgia. The resulting social, moral and legal history of this battle had consequences that still influence the Greater Atlanta area.

Although this book focuses mainly on Fulton County and the city of Atlanta, it also refers to areas that supplied the city with prohibition booze, including North Georgia and the Dixie Highway as a vein for alcohol supplies to the city from various islands in the Caribbean.

The general public is familiar with national Prohibition and its impact on the country. Much has already been written on the Eighteenth Amendment and the Volstead Act. The focus of this book is local and state prohibition periods and their effects. Few people realize the extent of the combined prohibition timeframe in Georgia and, therefore, Atlanta. Our aim is to illuminate this aspect of the city's history.

You will see variations of a few words in this book. *Temperance* is used in several contexts, as it was in history and, to an extent, today. First, it is used to denote a moderate consumption of alcohol. Second, it is used to define a social movement and the sentiment of the people within it. *Dry* with a capital "D" denotes the prohibitionists, while *dry* with a lower case "d" means a geographic area of legal alcohol prohibition (e.g. the county

had gone dry). *Wet* with a capital "W" denotes the anti-prohibitionists, while *wet* with a lowercase "w" means a geographic area of legal alcohol sales or illegal traffic.

The spelling whiskey and not "whisky" is used both in historical context and in modern form, as this is the developing trend among historians. If appropriate, a historical name of a beverage or substance is used supported by its modern name in parentheses. Quotes are provided as originally written or stated.

The reader will notice in several drawings a small caricature of a gopher tortoise. The "Gopher" was the historical mascot of the *Atlanta Constitution*.

The story of Atlanta prohibition cannot reasonably be captured in one book. Several theses and dissertations document this time period, and they, by necessity, also focus on a portion of the vast amount of information compiled. This book is a thoughtful cross-section of Atlanta's prohibition history, highlighting specific topics and events to give a general understanding of this dynamic period.

Chapter 1

# FROM FRONTIER FRENZY TO SEMI-DOMESTICATED DRINKING

*In its earlier frontier days, Atlanta had a reputation as a "crossroads village" that attracted rowdies, vagabonds, bootleggers, and prostitutes.*
—Tera Hunter, To 'Joy My Freedom, *1997*

## THE FRONTIER TOWN OF ATLANTA

In 1837, roughly six miles west of the town of Decatur in the Georgia wilderness, Western and Atlantic Railroad engineers studied the topography of land near the Chattahoochee River. Here they planned a terminus point for a future railroad, which would establish a more efficient means of commerce from the Mississippi River region to the Atlantic seaboard. As they drove a survey stake in the ground, engineers set in motion a series of events that would create a burgeoning railroad hub in the southeastern United States.

Wagon roads crisscrossed the backwoods, following what were once Native American trails, and a few taverns existed at these crossroads. The closest to future Atlanta was Whitehall Tavern—named for its unique whitewashed façade. A small hamlet generally known as "Terminus" sprung up around the end of the Western and Atlantic Railroad line once it was developed. Even with the early rail line in place, there were few amenities in the village. In lieu of a designated tavern, every house acted as an improvised inn for

travelers. Local unemployed railroad workers ran their own drinking and gambling houses.

As other railroad lines began tying into the Western and Atlantic, the future of Terminus brightened. The growing town was renamed Marthasville in 1843. From its early days, Marthasville was a destination for rural residents to barter their homegrown products for manufactured items. According to *Atlanta and Its Builders*, one of these rural products was "a very crude species of corn whiskey."

The Marthasville post office sat at the corner of the road that led to Peachtree Creek (Peachtree Street) and the road that led to the town of Decatur (Decatur Street). In the back of this early municipal building, Moses Formwalt ran a metal shop and a barroom. A popular item from his shop was a copper distillation pot, commonly called a "still." These stills were used by residents all over Georgia to make whiskey, brandy or any other distilled alcohol for which they had ingredients. His adjoining barroom is considered early Atlanta's first saloon due to its simple and open (not tavern-like) layout.

Once Marthasville became a railroad hub, long-haul wagon traffic began to flow into the town. These covered wagons delivered goods between the trains and rural Georgia. The town was quickly becoming the trade center of the region—a distinction that remains today. Regardless of growth, Marthasville was still a frontier town. Much to the consternation of the three primary religious denominations (Methodist, Baptist and Presbyterian), drinking, gambling and prostitution openly flourished. In these early days, Decatur Street began its infamous history as the "sporting section" of town.

Decatur Street between Peachtree and Pryor, now the border of the Georgia State University campus, was historically known as Murrell's Row. The area was named after noted Tennessee murderer John Murrell, who was apparently a common topic of conversation in this district. Murrell's Row is described as a series of wooden shacks built from discarded lumber. Half of these single-story structures were saloons. Drunken brawls were an everyday occurrence, especially on weekends.

In 1845, the town of Marthasville was renamed Atlanta. A few years later, the town of Atlanta incorporated as a city, and Moses Formwalt—the still maker and saloon owner at the end of Murrell's Row—was voted in as Atlanta's first mayor.

## ROWDYISM, SNAKE NATION AND SLAB TOWN

Atlanta was divided into two distinct political parties during the mid-nineteenth century: the Free and Rowdy Party and the Moral Party. Atlanta's first three mayors were members of the Rowdies. Mayors of the Free and Rowdy Party tended to be sympathetic to the saloon business and lenient on gambling and prostitution, which they saw as an integral part of city life. Generous for its small population in the mid-1800s, Atlanta sported forty saloons.

The Moral Party consisted of the evangelical Protestant congregations from the newly constructed churches and some of the people involved with city politics (what little of it existed). The Moral Party stressed temperance in hopes that it would reduce the civil disruption and sin in its city's midst. Temperance in this context meant the moderate use of alcohol as a beverage or complete abstinence by one's personal choice. Despite the Free and Rowdy Party's laissez-faire position, temperance-minded citizens put pressure on the residents of Murrell's Row. Many of the inhabitants of the area moved to the edge of the city limits and set up two shantytowns. These towns were well known for their vice and immorality.

Slab Town, named after the crude lumber and construction debris from which it was built, was located where Grady Hospital now sits. Snake Nation (currently Castleberry Hill) was west and south of downtown Atlanta on "the other side of the tracks." Many legends exist about why the area was called Snake Nation. One revolves around a Native American healer who sold snake medicine in the area. A second recalls a large number of snake oil salesmen in the area. The third is based on the residents of Snake Nation being "mean as a snake."

Atlanta's fourth mayor, Jonathan Norcross (1851–1852), was a member of the Moral Party. Son of a clergyman, he was described as highly temperance minded and intolerant of civil disturbance. To him and the presiding religious folk, the immoral sections of Atlanta needed to go away. He put moral, social and legal pressure on the elements of Atlanta life with which he did not agree. The rowdier elements pushed back.

One night, in response to Mayor Norcross's campaign against immorality, members of the Free and Rowdy Party traveled to the town of Decatur and filched the city's ornamental cannon. This piece of artillery from the War of 1812 was brought back to Atlanta and placed in front of the mayor's general store. The cannon was loaded with sand and gravel and fired, doing

minimal damage to the front of the building. Fortunately for anyone inside, no cannonballs could be located. However, the message was loud and clear.

What the rowdies failed to take into account was the organization, fortitude and zeal of the Moral Party. It was sufficiently organized to elect Jonathan Norcross and was backed by a growing church congregation. By 1847, the Sons of Temperance (a secretive temperance society) had established a chapter in the young town.

After arresting several of the leaders of the rowdies, a large group of Atlanta's men gathered to do something about the dens of iniquity. In a disturbing foreshadowing of future violence, they donned white hoods and attacked the residents of Slab Town and Snake Nation. After driving away the residents with whips and forceful removal from their homes, the hooded men burned the towns to the ground. This tolled the end of these rowdy shantytowns but not the demise of Decatur Street and Castleberry Hill.

## SEMI-DOMESTICATED DRINKING

With diligence and a growing law enforcement body, Atlanta learned to better enforce its city criminal code. This improvement separated the lawful public's social alcohol consumption from the criminal element of society. For example, most properly licensed and taxed saloons would not tolerate violent behavior or other activities that might compromise their profitable operations. The atmosphere of the drinking establishment resumed that of a social meeting place. The saloon now functioned not only as a place to get a drink but also as a social gathering spot, especially for lower-income workers. A saloon might provide mail service for those who did not have their own places or were new in town and even help people find a job. These functions were very similar to those carried out by eighteenth-century taverns.

In contrast to many taverns in history, the Victorian-era saloon did not generally welcome women. The sexes increasingly occupied different spaces, in part due to industrialization. The spaces were associated with gender roles: men went to work in segregated factories, and women stayed home in the domestic sphere. Drinking in public was labeled a male activity, since it occurred outside the home. From earlier social experiences in frontier life (like that of Slab Town, Snake Nation and Murrell's Row), women's public drinking became associated with sexual depravity. The Victorian mentality

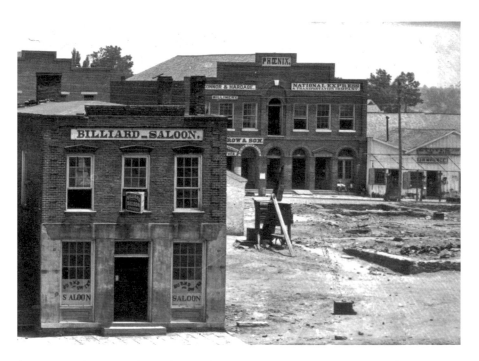

Detail of the Burns and Dwyer Billiard Saloon, circa 1866, after the burning of Atlanta. *Photo by G.N. Barnard, Library of Congress.*

held any alcohol consumption by women suspect; drinking was treated as a disease that directly affected children's lives and the family structure. The "respectable" women who could afford it drank in private at home. Those who wanted to drink but did not have family support often became users of patent medicines.

# THE SALOON

With a more industrialized population, the saloon became the preferred social meeting and drinking place for men. Laborers and a portion of the growing white middle class drank the majority of their beverage alcohol at the saloon. The best saloons had gas lamp fixtures hung from pressed tin or ceramic-lined ceilings. A straight, highly ornate wooden bar ran the length of the main room, complete with a brass rail for propping the foot. Behind the bar was an equally impressive mirror for reflection of light and to make

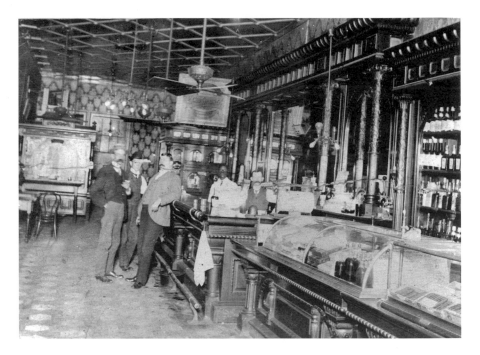

The interior of Mike Shurman's Saloon, Atlanta, circa 1905. *From the collection of Phyllis Levine and the Cuba Archives of the Breman Museum.*

the place seem bigger. Highly polished tile or wooden floors ran through the establishment. Side and back rooms often contained tables and chairs with carpeted floors and rich décor.

As a male-dominated social sphere, saloons offered concessions for the comfort of the customers. These included spittoons for the semi-accurate disposal of tobacco juice; public hand towels hanging from the bar; a free lunch for the hardworking and underpaid lads; new entertainments like the billiard table; and the all-around favorite precursor to the pin-up gal: nude artwork based on classic literature and paintings.

The bartender, mixologist and/or saloon-keep dressed nicely and behaved politely. His white shirt, apron or jacket reflected the cleanliness of the establishment. The space was grander and more spacious than most people's homes. It projected power—the power of community, the power of individual choice and the progressiveness of a gilded age.

Some Atlanta saloons were clean but far less ornate. Others were little more than a barrel house, a rough-hewn shack with dirt floors and little seating that contained a crude bar, dirty tinware or glassware and barrels

in the corner labeled with a single word: beer, brandy, whiskey or wine. A customer would hand over a coin and pour his own drink under the watchful eye of a barkeep holding a billy club. The disparity in saloons reflected class and race differences in Atlanta and would contribute to the ongoing tale of temperance and prohibition.

## PRE-PROHIBITION ALCOHOL IN ATLANTA

A young businessman visiting Atlanta in 1880 encountered a city of roughly thirty-seven thousand people. The steam whistles and bells of the arriving and departing trains at Union Station surely echoed off the nearby buildings, and the smell of smoke from businesses and locomotives drifted on the air. Vendors sold wares alongside the tracks at canopied tables, while both men and women moved along Decatur Street going about their business.

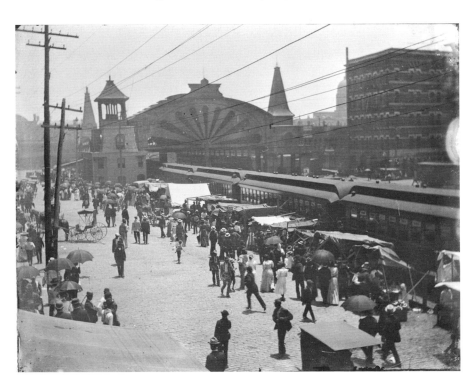

An 1893 Decatur Street photo depicting Atlanta's bustling Union Station and vendors of the open-air market. *Georgia Archives, Vanishing Georgia Collection, image number ful0116.*

Working his way through the bustling crowd, the businessman had only a short walk to the Kimball House hotel. Once there, he could relax a moment at the bar to fortify himself with a cocktail. When his business was completed each day, he might stretch his legs a bit by walking along the city streets. Contrary to our romantic visions, Atlanta's streets in the 1880s were a muddy mess, knee deep in some places and littered with livestock dung. Perhaps our visitor would instead have chosen to ride a mule-drawn streetcar to avoid the worst of the sludge.

If the businessman were of the "sporting" type, he could visit a saloon—perhaps the Girl of the Period for a game of faro and a drink? Seven years earlier, he might have played the card game with a young John Henry Holliday, later known as "Doc." Our visitor in 1880 had the option to stop into the Big Bonanza saloon conveniently located in the Kimball House complex.

If he were adventurous, the businessman might walk down Decatur Street. During the late 1800s and early 1900s, this busy and colorful street was compared to San Francisco's Chinatown and New Orleans' Canal Street. Described as a "kaleidoscope of light, noise, and bustle from dawn to dawn" in May 1913 by *Journal* magazine, Decatur Street was Atlanta's international melting pot.

The smells of fried-fish stands, tobacco smoke, chili con carne, cheap cologne, Chinese laundry steam and horses permeated the air. People crowded the sidewalks, and buggies clogged the street. The road was lined with delis, peanut vendors, ice cream shops, street auctions and an abundance of shoe shops and fish markets. The presence of the latter earned the area the nickname "Mullet Avenue."

People of all ethnicities crowded Decatur Street: Chinese, Eastern European, Italian, Irish, Greek and Jewish shopkeepers. A significant portion of this crowd was post-emancipation African American, and a growing number of small businesses were black owned.

A walk farther down Decatur would have led to one of Atlanta's eleven wagon yards. They functioned as a parking and temporary living area for country people who drove into the city to sell their wares. Many of these rural folk originated from North Georgia counties. The wagon lots were filled with old-fashioned prairie schooners with the unhitched mules and oxen nearby. Dressed in rough homespun clothing, mountain folk were warned by the police about the restrictions against illegal goods, public drunkenness and use of indecent language. Heedless of the warnings, many rural vendors offered untaxed white whiskey (moonshine) or brandy. According to

*Atlanta and Environs*, wagon folk were sometimes caught brazenly operating small stills within the lots.

In addition to illegal moonshine sales, Decatur Street also had Atlanta's largest concentration of saloons. Our research revealed roughly forty saloons along a two-mile stretch in the early 1900s, with most of the establishments concentrated near Five Points. A variety of beverage alcohol was sold by these saloons, nearby wholesalers, hotel and restaurant barrooms and pharmacies.

## Whiskey Distilling and Rectifying

Whiskey, both legal and illegal, has been sold throughout Atlanta's history. In 1868, Cox and Hill ran an *Atlanta Constitution* advertisement that they had "in store: 25 Barrels (Bbls) of Gordon County Copper Distilled Whisky, 100 Bbls Old Rye Whisky, 100 Bbls Old Bourbon Whisky, and 100 Bbls Rectified Whisky." Rectified in this context could mean blended and/or artificially aged to make it a brown distilled spirit.

Rectifiers often used unaged white spirits that were supplied by small-batch farmer distillers. These farm-distilled batches could be of unpredictable proofs and have unwanted flavors. The rectifiers would re-distill this whiskey and filter it through charcoal to homogenize the product. Better-quality rectifiers would then barrel age

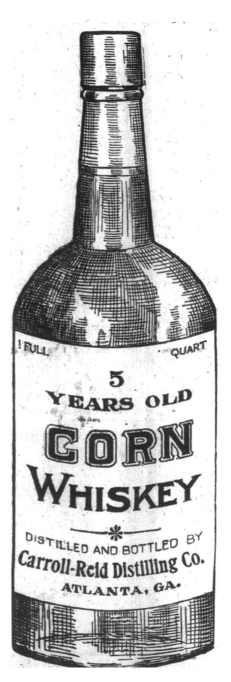

Detail from a Carroll-Reid corn whiskey ad in the *Atlanta Constitution*, December 1905. *Courtesy of www.Fold3.com.*

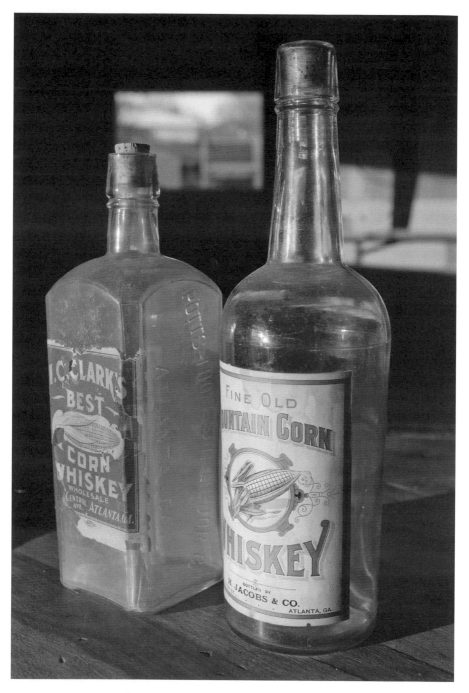

Two pre-1906 state prohibition Atlanta corn whiskey bottles. Potts-Thompson, rebranded for wholesaler I.C. Clark, and "Mountain Corn," bottled by H. Jacobs. *Ron Smith.*

the whiskey or sell it as unaged white whiskey. Cheaper products were produced by adding coloring and/or flavoring agents in an attempt to circumvent barrel aging. A few of these additives were plant-based extracts, syrups, sugars or even creosote (most likely the wood tar variety).

Whiskey was all the rage in the United States after the Civil War, and Atlanta was no exception. In 1880, companies like Bluthenthal and Bickart, Potts-Thompson, the R.M. Rose Company and at least ten other companies were distilling, rectifying or wholesaling whiskey (or some combination of these processes). From the postwar years until the first decade of the 1900s, legal whiskey production trended toward larger production distillers. The invention of the continuous column still gave distillers and some rectifiers a good source of high-proof, less-expensive spirits. Whiskey making had become an industry.

Product packaging and marketing followed suit. Throughout the nineteenth century, whiskey could be purchased in jugs and handmade bottles of varying sizes. After the advent of automatic bottle-making machines, all beverage alcohol was more commonly distributed in glass bottles.

## Beer and Brewing

Brewing was likewise becoming industrialized. From the 1850s through the late 1870s, Atlanta had four recorded breweries, but by 1880, only the Atlanta City Brewery remained. The brewery constantly expanded and likely out-produced its local competition. The influx of German immigrants in the 1850s had changed beer preferences across the country. Homesick for their national beverage, German Americans preferred lager beer to the more common ales. The Atlanta City Brewery, owned and operated by a mostly German American staff, brought this German-style beverage to Atlanta.

In the heat of the South, the light, crisp lager was welcome refreshment. The challenge was that making this type of beer required cooler temperatures that simply did not occur during summer. The Atlanta brewery built immense lagering (storage) cellars to clarify and store its lager beer. Coal-fired steam engines were needed to power the brewery and produce ice, a vital element in the manufacture, storage and transport of lager beer. The beer production was impressive for the time; by 1878, the brewery's on-site beer stock was typically four thousand barrels, or roughly 124,000 gallons.

The Atlanta City Brewery also owned the majority of local beer saloons. These "tied houses" were allowed to sell only the brewery's beer. Likewise, several of the whiskey saloons were owned by local distillers. The operator or saloonist

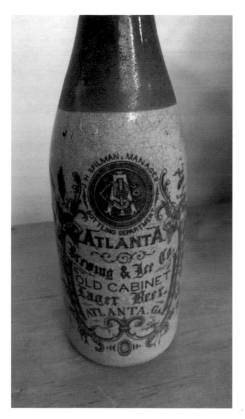

An Atlanta Brewing and Ice Company (formerly Atlanta City Brewery) Old Cabinet Lager stoneware bottle. From the breweriana collection of Ken Jones. *Ron Smith.*

paid rent on the establishment. In many circumstances, the brewery or distillery owned everything in the saloon, including the stock of alcohol, fixtures, furniture and even glassware!

Although prolific, the City Brewery did not produce all of Atlanta's beer. Wholesalers such as the Chicago Ale Depot and the Railroad Ale House imported beer from northern cities, including Chicago, Philadelphia, Cincinnati and Milwaukee. Beer was also imported from European countries, including Great Britain and Germany.

## Fortified Wine and Madeira

In eighteenth-century Georgia, wine was a scarce and expensive drink. Until the late 1840s, locally produced wine was thin-bodied and often tart. The lack of flavor and body was offset by additions of sugar or alcoholic spirits, most often brandy. Articles of the timeframe indicate that up to 25 percent of the total volume of some wines was actually brandy.

In 1868, the *Atlanta Constitution* ran an article that extolled the virtues of Madeira wine. Madeira is a style of oxidized and brandy-fortified wine originating from the Portuguese island of Madeira. This wine was aged in the holds of ships crossing the Atlantic, faring better in those transport conditions than most delicate wine styles. One port of call for these seafaring ships was Savannah, and from there it was a short rail trip to Atlanta. Madeira wine is mentioned throughout Atlanta's earliest newspaper articles (and we have felt an obligation to sample Madeiras that are available today).

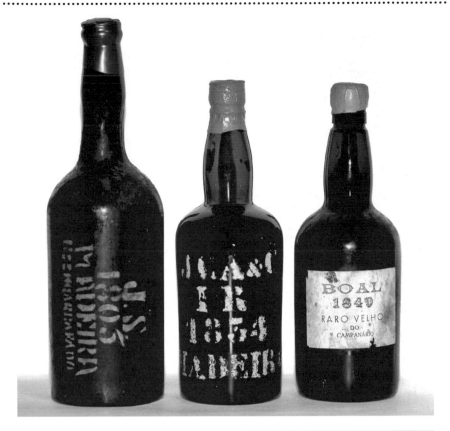

*Above*: Madeira bottles from the 1800s of
the type that made the transatlantic trip
to Georgia. *Photo courtesy of Andreas Platt.*

*Right*: A late 1800s "medicinal" wine
bottle from Pine Park, Georgia. *Ron Smith.*

Madeira remained popular until the early 1900s and was often used as a cooking ingredient. The popularity of wines imported internationally and shipped from California continued to grow. Soon, the only marketable native Georgia wines were blackberry and scuppernong.

Wine was often available at high-end hotel barrooms or upscale restaurants. Atlanta saloons occasionally carried wine, but whiskey and beer were much more common. Pharmacies during this time sold brandy and wines from France, Germany and California. Wine was marketed for use as medicine and for special-occasion cooking. This allowed respectable middle- and upper-class women to purchase wine or brandy for domestic use, increasing the customer base, regardless of whether the alcohol was really used for the more acceptable domestic purposes.

## CONFLICTING OPINIONS

To summarize 1880s Atlanta: The visiting businessman had a wide variety of libations from which to choose, including whiskies, ale and lager beer; an assortment of wines and brandies; or a cocktail mixed from these fermented and distilled beverages. An old-time alcoholic punch was available if he visited during the holidays. He could partake of a beverage in a saloon, restaurant, hotel barroom and possibly even direct from a wholesaler. Taxes associated with his purchase would add to the city coffers—building infrastructure in the rapidly growing metropolis. According to City of Atlanta records, almost 19 percent of the city's 1886 revenue came from the taxation of beverage alcohol.

Nevertheless, not everyone saw the freedom to purchase alcohol as a positive or even acceptable activity. Atlanta had a reputation for being a wild frontier town in its early years, but Georgia had a much older reputation for being the temperance state of the South.

Chapter 2

# TEMPERANCE IN GEORGIA, 1735–1884

*Time was when to advocate temperance in Georgia would be the death of any politician; but now all of that is changed, and to oppose temperance has become the most certain road to political death.*
—Honorable George Lester, Georgia attorney general,
Atlanta Constitution, *1883*

## EARLY TEMPERANCE AND PROHIBITION IN GEORGIA

### The Colony of Georgia

Most readers of history remember the 1851 "Maine Law" as the first major prohibition law in the United States. It may have been one of the first major laws within a state, but it certainly was not the first within a territory that would become part of the new nation. In 1735, England's Parliament, at the behest of General James Oglethorpe, enacted a law prohibiting the importation of ardent spirits (rum, brandies, spirits and strong waters of all kind) into the Colony of Georgia. Much of the sickness in the early colony was attributed to the "excessive drinking of rum punch." To support the diet of the early colonists, wholesome English ale was allowed, and the charter of the Georgia colony supported viticulture

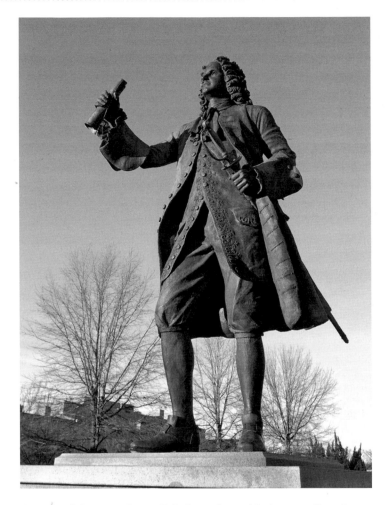

A statue of Governor James Oglethorpe located in Augusta, Georgia.
*Ron Smith.*

(wine making). The ardent spirits law, although nearly impossible to enforce, lasted in practice until 1742.

After repeal of the rum law, the General Assembly of colonial Georgia passed legislation for regulating taverns, punch houses and retailers of spirituous liquors. Even more laws regulating taverns were passed by the English colonial government before and during the Revolutionary War.

Shortly before Georgia was founded as a state, a 1786 law was passed legalizing taverns under the provincial government. This was Georgia's first alcohol retail license system, in place several months before the

signing of the Constitution of the United States of America. Seventeen years later, state legislation was passed that restricted taverns from opening within one mile of a church. This early requirement would prove prophetic, as the Protestant church would take the lead in growing temperance sentiment.

## Frontier Temperance

The temperance movement in the United States began in the New England area as a way to rid the church of drunkenness but expanded into a powerful social theme during America's Second Great Protestant Awakening. The awakening was a revival movement in the early nineteenth century (1800–1840). This movement was propagated by circuit-riding preachers who were guest speakers at a succession of local churches or camp revivals.

Temperate or moderate use of alcohol was commonly stressed during sermons while drunkenness was condemned. In some situations, church leadership would threaten excommunication for intemperance. This social pressure or personal conscience tactic was called "moral suasion." It was employed by the church and townships to influence individuals, though not by legal means, into adhering to doctrine.

Church membership among many Protestant denominations grew dramatically during this period, especially the number of female converts. This revival period exposed women to the concept of temperance, and church membership expanded the social sphere of women's influence on society, particularly in urban areas. Temperance greatly appealed to women who lived with men who abused alcohol. Women's rights to hold property, maintain family finances and legally gain divorces were severely reduced and, in many cases, impossible during this time. Temperance via moral suasion was an avenue for increasing a woman's and her family's chances of financial and emotional stability.

The Victorian morality of the time strengthened the ethics of the revival period, focusing on what was seen as "proper" family morals, exaltation of the church and removal of corrupting influences of human society. Temperance was a tool to suppress the damning influence of alcohol and move society toward a better place, ushering in a golden age of Christianity.

## Early Georgia Temperance Societies

Though a Baptist clergyman of Eatonton formed Georgia's first temperance society, Joseph Henry Lumpkin is regarded by many as the father of temperance in the state. In 1828, the young lawyer emptied his well-stocked cellar into the streets and took up a preaching circuit in Georgia and South Carolina. He was elected president of the Oglethorpe County Temperance Society in 1829. After successfully lecturing on temperance across the region, Lumpkin was elected as one of the vice-presidents of the Georgia State Temperance Society. This society was organized to practice moral suasion against alcohol use but disbanded in 1836 when some of its members began to advocate complete abstinence. This concept would later be known as "teetotal" temperance or "teetotalism."

Lumpkin, along with Josiah Flournoy, was a proponent of 1839 state legislation banning the sale of alcohol. This early Georgia temperance agitation was known as the "Flournoy Movement." Although the movement failed to pass any temperance laws, it did inspire future Georgia temperance activists. Lumpkin also served as chief justice of the Supreme Court of Georgia for over twenty years.

The Washingtonian Temperance Society was founded in Baltimore, Maryland, in 1840 by six men concerned by their alcohol abuse. They reasoned that by relying on one another for moral support, they could collectively beat their abusive habits. Atypical for the time, the Washingtonians had members from the working class and lower middle class.

Atlanta newspaper articles in the late 1800s and J.J. Ansley's *History of the Georgia Woman's Christian Temperance Union* mention the Washingtonians in Georgia and Atlanta in the 1840s. However, by the 1850s, this fast-growing national society had collapsed due to infighting and political differences. So thorough was the extinction of the Washingtonian Temperance Society that the founders of a similar society known as Alcoholics Anonymous in the 1930s had never heard of it.

Members of the Washingtonian movement in New York founded the Sons of Temperance in 1842. It quickly became one of the largest temperance organizations prior to the Civil War. By late 1847, it had a chapter in Atlanta. Unlike its parent society, Sons of Temperance was a semi-secret fraternal organization with formal rights, passwords, pledges and heraldry.

Alcohol manufacturers were not allowed to be members of this society. The Sons of Temperance, in Atlanta and elsewhere, showed a shift from moral suasion to teetotalism and legal prohibition. Their exclusionist

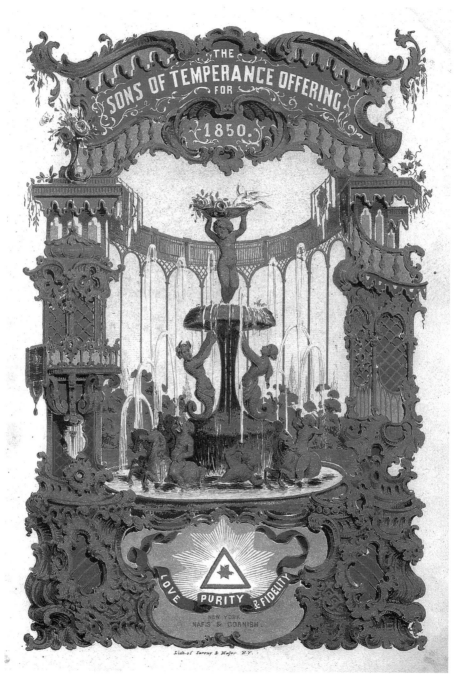

Artwork from the interior of *The Sons of Temperance Offering for 1850*. Nafis & Cornish, New York, 1850. *Collection of Ron Smith.*

methods appealed to some social elitists and politicians, giving the society some influential friends. The organization was at its strongest in the 1850s but was fractured and weakened by the Civil War. Although the Sons of Temperance would survive in Atlanta after the war, it would play a lesser role to more powerful temperance associations.

Other early temperance societies that had local chapters included the Knights of Jericho, the Good Templars, the Temperance Family, Cold Water Templars and Knights of Temperance. Atlantans organized the first Georgia chapter of the Independent Order of Good Templars in 1867. No southern city rivaled Atlanta in its number of temperance societies or card-carrying temperance proponents.

The Georgia State Temperance Convention met on February 22, 1855. The congregation represented twenty-eight counties and totaled over eighty delegates. At this meeting, the group nominated Basil Overby, a lawyer from Atlanta, to run for governor of Georgia on a prohibition ticket. In a letter accepting his nomination, Overby stressed that he wished to repeal the liquor license laws, prohibit the sale of any quantity of beverage alcohol (excluding sacramental, mechanical and medicinal alcohol) and make a determined effort against grog shops.

Overby traveled across the state speaking in just under twenty locations. Of the gubernatorial candidates in the 1855 Georgia election, he received the fewest votes. Allen Tankersley sums it up nicely in his comprehensive journal article "Basil Hallam Overby: Champion of Prohibition in Antebellum Georgia": "He sought public office on a purely moral platform and up to the present he still holds the distinction of being the only Georgian who has run for Governor on a straight prohibition ticket."

# ALCOHOL IN CIVIL WAR ATLANTA

Although temperance sentiment did not disappear during the Civil War (1861–1865), it took a backseat due to the brutal hardships and realities of a war on Georgia's soil. While men went off to fight, wives and daughters took their places on nearby farms and in the city. This amplified female role in society set the stage for women's involvement in later prohibition reforms as well as the women's suffrage movement.

During the Civil War, alcohol production declined in some regions of Georgia as distillers and brewers were off fighting. However, the market for

medicinal alcohol increased dramatically, and the beverage alcohol trade held its ground. Wounded soldiers at battlefield dressing stations received whiskey and/or opium to deal with pain during and after surgery. Once in the hospitals, they were given frequent small doses of brandy, whiskey or a punch mixture.

Moonshiners smuggled whiskey into Atlanta under the pretense of taking it to hospitals. Unsurprisingly, much of the load never made it to the wounded. The governor received reports from North Georgia that some distillers would not share grain with starving people due to the immense profits made from whiskey during the war years.

Starting with his first general order, Captain George Lee—one of Atlanta's Civil War provost marshals—banned the sale of alcohol to members of the military. Anyone caught drunk in the streets was arrested. On his orders, the guard inspected wagons and emptied into the street any illegal barrels of whiskey. Atlanta's Confederate provost marshals found upholding wartime prohibition on alcohol one of their hardest duties. When Governor Joe Brown eased restrictions on alcohol prohibition, supposedly to help supply the hospitals with medicinal whiskey, bootlegging operations increased.

Due to the city's importance as a railroad hub, the Confederacy used Atlanta as a key military supply center. It was also an important manufacturing asset for the South, making Atlanta an important strategic target for the U.S. Army. During General Sherman's siege, the city reportedly endured thirty-six days of artillery shelling. Most of the city's population fled before and during the shelling. Only three thousand civilians remained in the city after the Confederate army withdrew.

The military and financial infrastructure of Atlanta was destroyed by the Federal army in October and November 1864 before it marched onward. According to some historical estimates, as much as 40 percent of the city was destroyed.

## POSTWAR FIRE AND BRIMSTONE

Although the fire of the Second Great Awakening had cooled before the war, and the war had nearly destroyed the city, temperance sentiment seems to have been sustained throughout Georgia. Atlanta was seeking to redefine itself in the ashes of the Civil War and the post-slavery economy. Both black and white citizens expressed an interest in Atlanta's continued prosperity.

Whether expressing a desire to return to a prewar type of society or embracing the prospects of a New South, prohibition-minded civic leaders felt that temperance should be a part of Atlanta's revival.

As with earlier such agitation, this period of temperance sentiment in Atlanta (1870s into the early twentieth century) rose on a tide of religious activism. Traveling tent revivals with celebrity fire-and-brimstone preachers encouraged pious Protestant denominations (mostly Methodists and Baptists) into social activism. This activism fostered the belief that the golden age of Christianity would occur only after mankind had reformed the entire earth. This religion-driven reform seemed tailor made for a city rising out of the ashes of war.

Sam Porter Jones, an ex-alcoholic former lawyer from Cartersville, became a preacher after promising his dying father that he would give up alcohol. He was known to be energetic, theatrical and crude, but in a humorous manner. Although Jones had a peculiar style of theology for his day, he was a wildly successful circuit preacher. It was not unusual for him to repeatedly preach to crowds of more than twenty thousand people. His extensive travels spread his words all across North America and especially to his home region in the Southeast.

Sam W. Small, a freelance writer for the *Atlanta Constitution*, was covering one of Jones's sermons in 1885 and was deeply influenced by his preaching. After one last drinking binge, Small began lecturing on the evils of alcohol to anyone who would listen. Using his contacts as a journalist, he secured positions at temperance revivals and became a regional presence in the prohibition movement. In 1889, he wrote the book *Pleas for Prohibition* and financed its publication the following year. Anti-prohibitionists frequently noted the evangelical fervor of the Jones and Small duo.

Samuel W. Small, the prohibitionist preacher who authored *Pleas for Prohibition*. *Biographical Review of Prominent Men and Women...*, 1888. *Collection of Ron Smith.*

# THE WOMAN'S CHRISTIAN TEMPERANCE UNION

Despite masculine predominance in the early temperance movement, its first truly successful organization originated with the "weaker" sex. The Woman's Christian Temperance Union (WCTU) was birthed in Cleveland, Ohio, in 1874. Eliza Thompson, Mrs. George Carpenter and Eliza "Mother" Stewart founded this new organization. They were inspired by the work of the semi-successful Woman's Crusades, where women began staging saloon sit-ins. Most WCTU members still agreed with the approach of moral suasion. However, Carpenter advocated the need for "legal suasion" against the liquor trade. Corresponding secretary Frances E. Willard developed a Plan of Work for the evolving organization.

The WCTU motto was "For God and Home and Native Land," and it planned its movement around safeguarding the home. This mantra allowed the women to expand their social influence by tying society to the feminine role of home protection. To symbolize purity, they chose the white ribbon bow. To become members of the WCTU, women pledged to not drink intoxicating beverages, to not cook using them and to not furnish them in social entertainment.

The thesis "Woman's Christian Temperance Union in Georgia, 1883–1918" notes that the WCTU also created the White Cross Club for young boys and White Shield Societies for young girls. This was done as a preventive

A WCTU lapel pin "white ribbon," the symbol of the organization. *Ron Smith.*

measure against societal intemperance. The young participants had to pledge "to be modest in word or deed and to discourage profane and impure language; never doing or saying anything that I would be unwilling to have known by my mother and father." Young members agreed to avoid all talk, reading or "amusements which may put impure thoughts into my head."

The organization's watchwords were "Agitate—Educate—Legislate." The local chapters were mostly autonomous but linked to state unions and the national headquarters in a clear channel of communication and authority. The WCTU ultimately became the largest and most influential women's organization in United States history.

# THE ATLANTA WCTU

On April 20, 1880, the Atlanta WCTU was formed when the Georgia Good Templars invited Mother Stewart to speak at Trinity Methodist Church. Stewart organized the chapter and elected its first officers. The *Daily Constitution* reported that two hundred women joined at once and one hundred more when Stewart spoke again at a Baptist church. During the same visit, she also organized the South's first African American WCTU at the Storrs School in Atlanta.

In the following year, Frances Willard visited Atlanta for three days. She had been elected president of the National WCTU in 1879, becoming the organization's most dynamic leader. She spent more time traveling and campaigning than most U.S. presidents. In her developing role at a national level, she pushed for legal suasion via the Home Protection ballot. She argued that women, being the morally superior sex, needed the vote in order to act as "citizen-mothers." In this aspect, they were working within their role as protectors of their homes and could exercise power to cure society's ills.

While in Atlanta, Willard gave eight speeches at the Marietta Street Methodist Church and DeGive's Opera House. Although many people in local clergy and society were against women engaging in public speaking or taking part in social campaigns, they were impressed by her intelligence and oratory skills. After her visit, the Georgia WCTU women were less fearful of undertaking public work. In her thesis recounting thirty-five years of the WCTU in Georgia, Glenda Rabby captures Willard's words of encouragement: "Think of your work, she told them, as merely 'enlarged housekeeping.'"

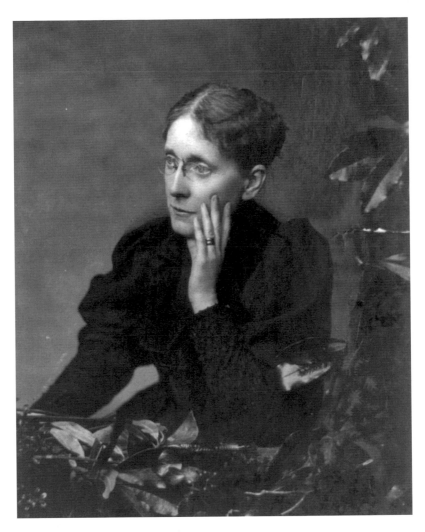

Frances Willard, president of the national WCTU from 1879 to 1898 and one of the most influential women in American history. *Library of Congress.*

Frances Willard was convinced that the key to a reunited country with temperance and reform lay within southern women. She campaigned alongside them, encouraging women as protectors of the home and instruments for reestablishing the link between North and South. With the influence of Eliza Stewart and Frances Willard, along with a few other local and national temperance leaders, Atlanta's temperance movement coalesced into an organized force for change.

# THE ORIGINS OF LOCAL OPTION

Georgia was one of the first three states to experiment with local option and the first southern state to do so. Under local option legislation, the local political body (typically a county or city) would decide whether liquor licenses would be granted or the sale prohibited to varying degrees. By 1859, thirty-two counties exercised some form of local alcohol prohibition.

In 1881, under the guidance of Judge John Cunningham, the Atlanta WCTU adopted a resolution requesting that the Georgia legislature pass a General Local Option Law (statewide law). This law would streamline the process for voters to decide by ballot whether each county would prohibit the sale of intoxicating liquors (with certain exceptions). This first attempt at a Georgia Local Option Law passed the senate but was defeated in the state house. The WCTU and other temperance advocates attempted multiple times, from 1881 to 1884, to pass the law granting local option and a law requiring mandatory temperance education in Georgia public schools.

Regardless of their growing unity, prohibitionists had to pass laws one step at a time over a long period. Taxes on alcohol provided Atlanta and other Georgia cities with essential funds to build and maintain roads, bridges and other city infrastructure; the education system was also maintained from this lucrative tax resource. The evangelicals among the prohibitionists were against what they saw as a sin tax. They also argued that revenues from a liquor license made the alcohol business seem respectable and legitimate. In sum, they saw all businesses involved with beverage alcohol (producers, distributers, wholesalers and retailers) as inherently immoral.

Despite the legal and societal hurdles, an August 1885 *Atlanta Constitution* article reported that the Georgia legislature had passed 168 acts prohibiting the sale of alcohol in some form from 1873 to 1883.

Chapter 3

# THE BATTLE FOR FULTON COUNTY

*The battle is o'er, the victory won,*
*Prohibition has saved, saved her son;*
*The blue ribbon triumphs over the red,*
*The goggle-eye monster, drink, is dead.*
*—From the song "Prohibition Victory in Atlanta, GA" by Dave Sloan*

In June 1885, the *Atlanta Constitution* ran two lengthy articles—"Against Whisky" and "Claiming the State"—detailing the ongoing state temperance convention. The articles reveal just how far coordination among the temperance organizations, temperance authors and public speakers had progressed. Emory professor Henry A. Scomp, who would write *King Alcohol in the Realm of King Cotton* three years later, was in attendance. Temperance advocates from the Independent Order of Good Templars, the Prohibition Club of Fulton County and the Woman's Christian Temperance Union were also on hand. Ms. Missouri Stokes spoke for the WCTU, saying that the union believed "in moral suasion but they ask also to have the strong arm of the law to crush this evil."

The convention resolved that "all members of…any temperance society or organization whatever, and all ministers of the gospel, and all temperance people in the state…be and are hereby made members of the Georgia State Temperance Association, and are competent to enter the ranks and fight its battles for God, and home, and humanity." They vowed to use their combined influence to push state legislators to pass laws advocating

prohibition. They also recognized the importance of the African American vote in carrying any popular movement.

After many failed attempts by Georgia temperance groups, the General Local Option Bill passed the legislature in the summer of 1885 and was promptly signed into law by the governor. The bill stated that upon receipt of an application for prohibition, signed by one-tenth of the voters in any county, an election would be called to determine whether spirituous liquors could be sold in that county. The tickets (ballots) shall be written *for sale* and *against sale*. Interestingly, local option did not preclude domestic wines or mail-ordered liquor.

Opponents of this law argued that it was an act to promote the wine industry in Georgia, as there was more in it to encourage the manufacture of domestic wines than in any bill ever passed in state history. In an *Atlanta Constitution* interview, a liquor license advocate stated that imposing prohibition "will run the orderly police regulated saloon out of business and that 'little sinkhole barrooms hidden in the sewers and cellars' out of the reach of the police will become the norm." Many residents criticized the temperance groups and the Georgia legislature for attempting to suppress individual freedom by dictating what they could or could not drink.

For the first time, local brewers, wholesalers and distributors began to take note and worry over the growing temperance sentiment in the city of Atlanta. In 1870, Hans Muhlenbrink (a saloon owner and liquor wholesaler) organized the Atlanta Liquor Dealers Protective Association. The organization held a well-attended meeting in 1882 to discuss growing concern about temperance. The Atlanta City Brewery was a member of the United States Brewers' Association, but the association was slow to respond to the temperance movement. Newspaper articles indicated that monetary and legal offers of support to combat the local prohibitionists were received from brewers in the West and North and from liquor dealers elsewhere in the country. In 1885, the anti-prohibitionists joined the Mutual Aid Brotherhood, the political arm of the Knights of Labor, to form a focus group and, later, a political platform against prohibition.

The first common references to the term "Dry" associated with the prohibitionists or the "Prohibs" and "Wet" in association with the anti-prohibitionists, or "Antis," appeared in the late 1870s. In the 1880s, these abbreviations became more common in newspapers and allowed for streamlined reporting on this growing topic.

The WCTU wasted no time in gaining the signatures needed to apply for a prohibition vote in Fulton County. During its 1881 to 1884 attempts to pass legislation, it had become expert at gaining support by signature.

In the nineteenth century, petitioning was a common method of influence used by reform groups. Because women could not vote, petitioning was their sole means of influencing the government. With signatures gained, the vote was ensured, and by October 1885, Atlanta newspapers were running ads urging Atlanta citizens who had paid their taxes to register and vote in the upcoming Fulton County prohibition election.

Both Wets and Drys paid to have Atlanta newspapers print articles supporting their viewpoints. As the November date for the local option vote got closer, the number of opposing articles grew. The Wets pushed for higher cost or "high license" instead of prohibition via public vote. In their opinion, a higher license was preferable to being completely run out of business. A high license could be afforded by the wealthier liquor dealers, and it would also handicap their less affluent competitors. Business owners who rented to liquor wholesalers, manufacturers and saloons were also concerned. Their high-rent properties could become liabilities overnight. Atlanta business owners in general were worried about the economic effects if prohibition passed. The South had just gone through a time of economic depression from which many of the city's largest businesses were only now regaining a foothold.

# AFRICAN AMERICANS AND THE FULTON COUNTY VOTE

The Civil War brought immense change to the state of African American slaves. As the U.S. Army marched through Georgia, many slaves took the opportunity to flee. Camps set up by Union forces provided food and shelter for many of the newly emancipated freemen. Retaliations by rural ex-Confederates and other vigilante groups pressured blacks to enter cities to find relief; in this respect, Atlanta became a seemingly safe harbor.

For African Americans, the city of Atlanta was a paradox. It offered strength in numbers and a sense of community; however, it also represented despair in the form of disenfranchisement, namely Jim Crow laws and police violence. The influx of the newly freed slaves—along with ex-soldiers, northern businessmen, wartime runaways, U.S. Army troops and immigrants—generated a population explosion. It also resulted in palpable post-war tensions between many groups. *To Joy My Freedom* notes that between 1860 and 1870, the black population in Atlanta increased from 1,900 to 10,000, more than doubling representation in the city's population (from 20 to 46 percent). This demographic shift and

the rights of African American men to vote made Atlanta's black population critical to the local option battle.

Prohibition was an important issue among African American ministers, civic leaders, political leaders and noted educators. Black ministers were united on the issue: prohibition was the way of Christianity. *To Build Our Lives Together: Community Formation in Black Atlanta, 1875–1906*, describes the movement: "African-American leaders in the prohibition camp argued that by supporting the cause, they were aligning themselves with the 'best people' in Atlanta and demonstrating their own high moral standards." The black community was also promised improved race relations through a higher level of sobriety across races.

However, some noted African American businessmen were moderately to strongly anti-prohibitionists. Many worked for the saloons, hotels, restaurants and other businesses where alcohol was sold. While African American civic leaders may have been prohibitionists, the average citizen was either neutral on the issue or had a vested interest in the service industry. Many black Wets argued that if prohibition were passed, only the rich would be able to legally obtain alcohol. To African American anti-prohibitionists, having the ability to drink alcohol was a validation of their full citizenship. During slavery, Georgia liquor licenses had required the recipient to swear that he would not furnish alcohol to slaves.

On October 29, 1885, a meeting of four hundred African American Wets was held at Thurman Hall. This meeting was led by the employees of the Kimball House, reported by *South Atlantic Quarterly* as the largest hotel in the city. Black employees were concerned over potential blows to employment if Fulton County went dry. This worry was also voiced by black employees of the Atlanta City Brewery.

Essentially, the African American residents of Atlanta were split on the issue of temperance and prohibition. Wets and Drys of all races in Atlanta would court the African American population as an important swing group in the looming local option vote.

# THE VOTE

Residents of Atlanta began wearing badges, ribbons or pins showing solidarity with others on their side of the vote: blue for Drys and red for Wets. A pamphlet entitled *An Appeal to the Voters of Atlanta* was issued by an ambiguous

anti-prohibition group called the Committee of Twenty-Five. The handout defined the logic of the wet platform, expressing the belief that prohibition laws would create intemperance more widely spread than that which the laws intended to cure. It also called for economic progress, imploring that "instead of becoming crazy on religion and fanaticism, let us rather devote our time and energy toward the building up of our city, encouraging manufacturing interests, which gives employment to our population." In a statement that would be humorous if there were no supporting evidence for its truth, the pamphlet declared that the Drys "even oppose baseball, theatres, card playing, dancing, and what not."

For two weeks in mid-November 1885, the Drys held a large tent revival in downtown Atlanta. There, the duo of Reverend Jones and Sam Small proselytized on the evils of intemperance. The WCTU began prayer meetings weeks before the election. Both Wets and Drys had multiple campaign headquarters, where voters could get help registering or the latest information. Prohibition headquarters were kept open overnight before election day.

The Wets organized a feast along with beer at the West Point Depot for their supporters on the eve of election. Drys accused the Wets of "bullpenning" the lower class of Atlanta to raise votes. The term *bullpen* meant the opposing force had plied a large group of people with food, liquor or other vices and then herded them to the polls on election day. The Drys had their own organized feasts at each of the churches involved with campaigning. Female prohibitionists also offered a free lunch near the polling locations to provide the lunchtime voters with more time to vote. According to the *Atlanta Constitution*, the Drys spent around $10,000 on their campaign effort (roughly $260,000 in 2015 dollars after adjusting for inflation).

On the day before the election, both sides formed long processions with wagons, brass bands and signs, parading up and down city streets. The Drys included the Young Men's Prohibition Club, while the Wets marched with the Young Men's Anti-Prohibition Club. Betting on the outcome of the election was also prevalent, with wagers ranging from $50 to $5,000.

The day of voting, November 25, was clear and cold with a whistling wind. The anti-prohibitionists hoped that cold weather would help their cause because a warming dram of whiskey would be on a voter's mind. However, both sides were confident that victory was theirs. The wild card was the African American vote.

Atlanta residents walked to the polls in singles, groups and parades. H. Paul Thompson's *A Most Stirring and Significant Episode* recounts, "One indicator of

The front and back of the "angel ticket," used by dry voters as a ballot in the 1885 Atlanta local option vote. *Collection of Ron Smith.*

engagement in the election was the voter registration—more citizens registered than for any previous election in Atlanta's history." As required, ballot tickets were written "for sale" and "against the sale." However, the dry ticket also had the image of an alcohol imbiber walking off a cliff into hell while an angel beckoned him back from the precipice. Because of this imagery, the physical ticket, and the Drys' platform, was known as the "angel ticket."

In a surprising narrow-margin victory that shocked the state and the South, Fulton County voted dry (various sources cite a dry margin of 219 or 229 votes). Atlanta had become the largest city to ever go dry by popular vote. The city was seen as a bellwether for southern temperance, and this victory sent the message that anything was possible.

As foreseen, the Drys received a strong rural vote. Rural citizens of Fulton County viewed Atlanta as singing a corrupting siren song to their communities and were happy to vote the city dry as long they could keep wines produced locally. The African American swing votes likely gave the Drys their victory. Thompson notes that the 1885 campaign was especially remarkable because it "simultaneously blurred both racial and party lines, surprising virtually all political camps."

## THE AFTERMATH

The narrow margin of the vote indicates how strongly the city was divided on the issue. In an ironic twist, liquor licenses in Atlanta did not expire until July 1886. Municipalities are notoriously loath to return tax money, so the city allowed operation until the permits expired. Out of the one hundred or so saloons in Atlanta, less than one-third shut down immediately after local option. Locations such as the bar within the Kimball House, the Atlanta Globe and the Big Bonanza continued business as wine rooms, though the wine business was not as strong.

June 30, 1886, the day prior to expiration of the county liquor licenses, was a busy day for saloons and wholesalers. People were having their last shots of whiskey and mugs of beer, though most citizens were buying bottles, jugs, demijohns (a five- to fifteen-gallon container) and even barrels of whiskey, brandy and other soon-to-be-prohibited beverages. Ladies of all classes were seen at wholesalers stocking up for prohibition cooking. Streetcar companies were making quite a profit ferrying the larger containers to private residences. The mayor of Atlanta purchased a barrel of whiskey for personal use just prior to the new law's going into effect.

The saloons tried to sell as much of their stock as possible up until midnight. The following day, they had to open as wine rooms, make a go of

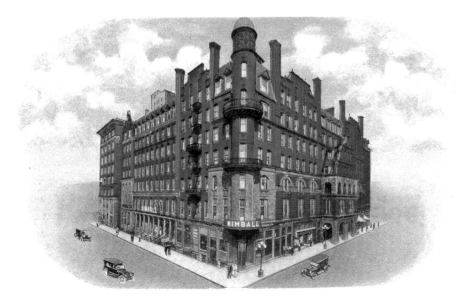

Kimball House (1885–1959), built after the previous hotel burned, on the corner of Five Points in downtown Atlanta. Imperial Post Card Company, early 1900s. *Collection of Ron Smith.*

it as restaurants or other businesses or close shop. Some of the closed saloons had notes pinned to their doors. The *Atlanta Constitution* quoted a sign at 52 Peachtree Street as reading, "Closed on account of the death of the leaders of prohibition and the birth of this ruin." Maher's Mitchell Street saloon had black mourning cloth draped on the door and a note declaring, "Closed in respect to the death of Atlanta."

Four not-so-minor details were overlooked in the writing of the local option law:

- A strict definition of "domestic" or native wines was not established. Within a short period of time, though, domestic was finally interpreted as originating from any state in the United States.
- Wholesale liquor licenses were issued by the county and not the city, and they expired in August and September (in one case December 1886). This gave the wholesalers a liquor trade monopoly for a few more months.
- The minimum legal pour (vend) amount was a quart, and several styles of wine bottles were less than a quart of total volume. This large minimum purchase limit was an attempt to discourage "shots" and six-ounce pours, which were common in saloons (not to mention less expensive and therefore popular with the working class).
- Atlanta's City Brewery could continue to legally produce beer but could not sell it within Fulton County. This loophole led to many workarounds.

As saloons closed, the wholesale business exploded. An *Atlanta Constitution* reporter noted that a single business, Paul Jones Wholesale Liquor House, sold nine barrels in one day. This amount could vary due to barrel size, but if the standard 31-gallon barrel is applied, that amounts to just under 280 gallons. This wholesaler expected to sell five hundred barrels before its license ran out one month later. Those who could afford to do so were stocking up for the dry year until the next vote.

## The First Challenge

In July 1886, the Fulton County Local Option Law had its first challenge when the Big Bonanza and the Kimball House threw down the gauntlet. The wholesale liquor license of M.J. Mabry was transferred to No. 23 Decatur Street, a shop adjoining the Kimball House. There, quart-sized pitchers of beer, whiskey and cocktails were being sold "wholesale." The patrons would

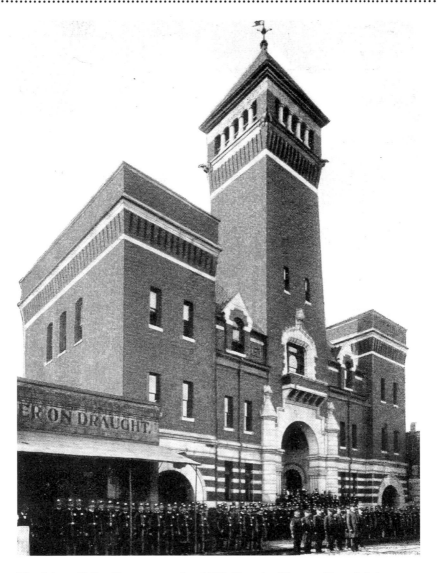

The Atlanta Police Department, circa 1895. Note the "Beer on Draught" sign on the saloon next door. *Collection of Dr. Richard Funderburke.*

take their purchases out a back door and walk into the Kimball House wine room. The wine room did not sell anything but domestic wine; however, it provided glassware to share anything that someone had perhaps bought elsewhere. Just above No. 23 was the Big Bonanza, which had become a wine room due to prohibition. The Bonanza had also transferred a county wholesaler's liquor license. This establishment sold beer out of tin cans that

were slightly larger than a quart. From these cans, patrons could distribute the beverage into individual glasses in the Bonanza's wine room.

The day after the liquor license transfers, police requested that the Big Bonanza shut its doors or the owners would be arrested. They complied and shut their doors to await a court decision. Events happened differently at No. 23 Decatur Street. Police arrested license holder Mabry, along with Charles Beermann (one of three owners/investors of the saloon), when he refused to stop pouring beer. Likely, the establishment was a tied house of the Atlanta City Brewery, as Beermann was an investor there as well. Four years later, he would replace H.G. Kuhrt as president of the brewery.

This same month, Charles Thorn—a Whitehall Street grocer, well-known prohibitionist and member of the Young Men's Prohibition Club—made a stir by getting arrested for selling liquor. The city was unaware that Thorn had a liquor license for his grocery store. Much to the shock of the Drys, he decided to sell his stock on hand until a court decision was made or his license ran out.

The Atlanta City Brewery continued to produce beer and sell outside the county but initially did not sell its beer openly in Fulton County. Large purchases initiated *before* local option were segmented into scheduled shipments of fresh beer to wholesalers who still retained licenses. Their ice deliveries continued to make the rounds within Atlanta as the city council arrived at a decision.

On October 5, 1886, the city council voted to let the brewery sell its beer in Atlanta. One of the main arguments was that any beer could be purchased outside Fulton County and shipped into the county. The Drys were

Jennie Hart Sibley, an early president of the Georgia WCTU. *The Passing of the Saloon*, 1908. *Collection of Ron Smith.*

not happy with this decision or the troubles the licenses were causing. They organized and spoke at city council meetings against the brewery sales and the underhanded tactics of the wholesalers. Representatives of the WCTU also spoke at meetings, condemning the selling of beer in Atlanta.

The final weeks of October 1886 were a turning point in Atlanta prohibition. The court ruled against Thorn's license, stating that licenses issued by a clerk and not the commission were void. Other retailers in similar situations began closing. The mayor vetoed the city council's decision on the brewery, and the Atlanta City Brewery had to stop delivering beer in Fulton County. By November of the same year, regardless of the unclear legal language, police were making more arrests of owners and sellers for operating houses that sold legally (wholesale) but offered a convenient means to drink "by the glass." This was the end of most of the quasi-legal sale of alcohol in Atlanta yet only the tip of the prohibition iceberg.

## Enter the Blind Tiger

There are several hypotheses about the origin of the term *blind tiger*. One is that it originated in England, where a town had only one legal tavern named the Tiger. All the illegal taverns within that town were called "blind tigers." A second and better-known explanation is that a quasi-legal bar could be run by selling tickets to see an animal oddity and giving away "free" drinks. Evidently, the first animal oddity was a blind tiger. The third notion is that the illegal alcohol transaction itself is "blind." Leave your money in a hollowed-out fence post, come back a bit later and a bottle of whiskey awaits you. The tiger in this theory comes from the term *tiger whiskey*, referring to poor-quality booze that will claw your guts out.

The term blind tiger was used flexibly. It could mean the location where illegal alcohol was being sold, the person doing the selling or even the alcohol itself, such as "blind tiger whiskey." Blind tiger first appeared in Atlanta newspapers around 1884, and it was not explained, leading the reader to infer that it was a known term. The word *speakeasy* was commonly known yet used very infrequently in Atlanta until after Prohibition ended. An occasional alternate term for blind tiger was *blind pig* (and on very rare occasions, *striped pig*).

According to local newspapers, the city's first blind tiger arrest happened at 55½ Broad Street on July 19, 1886. This address belonged to a series of rooms occupied by two German men above a brick company. The crowd

of people gathered on the street near the stairway to the rooms gave away the illegitimate business. Upon inspection by the police, drinking glasses and tables were found, and there was evidence that beer had been consumed. The two men were arrested, taken to the police station and released on bond. Despite much evidence, Atlanta's first case of this type was dismissed on the grounds of failure to show that money had been exchanged for the beer.

The most sensationalized early blind tiger case was that of Lucy McCall, a sixteen-year-old African American girl who was selling liquor in her parents' house. Small quantities of corn and rye whiskey, peach brandy and wine were found in nearly empty bottles in the residence at the corner of Highland and Boulevard. She was arrested and put on trial. Witness testimony in the trial declared that she would sell a quantity to young men for ten to fifteen cents, unbeknownst to her parents. She testified that the money was given to her independent of the alcohol. She was acquitted on charges of breaking the prohibition law but heavily fined for selling alcohol to minors. Sources suggest that McCall's case was but one of fifty-six blind tiger cases between July 1886 and March 1887.

## Everybody's Got Something on the Jug Train

If an Atlanta resident did not want to risk dealing with a blind tiger, he or she could order liquor for delivery from a nearby wet county. Said purchase could arrive via train the same or following day. In February 1912, Gordon Hurtel wrote an article about Atlanta's 1880s prohibition years for the *Atlanta Constitution*. He mentioned the phenomenon of the jug train: "Twice a day it rolled in from Griffin—that was one thing which gave that town a real place on the map—and it was loaded down with jugs of all sizes, from the 'little brown' to the demi-john, and beading with every brand, from the green corn to the mellow rye." Other sources list Augusta, Gainesville and Macon as Georgia towns supplying booze to Atlanta via jug trains.

To order alcohol from this jug trade, a person located an agent for the wet county wholesaler and put in an order. The orders were then telegraphed to the distant business, and the package was put on the next train to Atlanta. The assumption is that all monetary transactions were handled by the out-of-county business. The Wets called the trains the "Juggler" and the Drys named it the "Juggernaut." Atlanta even developed cost-effective social

## The Prohibition Campaign

**THE EXPRESS COMPANIES ARE BUSY DOWN IN DIXIE.**
**PROHIBITION DOES NOT PROHIBIT.**

A postcard depicting a jug train delivery. *Courtesy of Moody's Collectibles Inc.*

clubs around the jug train, where people pooled their money together, made a large order and shared the shipment at gatherings.

In July 1887, the Georgia senate introduced a measure attempting to outlaw any railroad or express company transactions delivering liquors into a prohibition area of the state. The bill failed, and the jug train concept had just started rolling. It would be over two decades before the jug train would lose steam.

## ATLANTA'S FIRST TEMPERANCE BEVERAGES

With 1886 effectively being Atlanta's first dry year, temperance beverages made their appearance. These beverages were clandestinely produced alcoholic beverages, imitations of alcoholic beverages or an alternative to them.

One of the first local references to rice beer appears in the *Sunny South* magazine in late 1887. Reverend Jones describes it in one of his Atlanta sermons as being "made of spoiled lager beer and mean whiskey." Jones was no doubt trying to be dramatic, as spoiled lager would not sell well—with or without whiskey. More likely, rice beer was the brewery's standard lager beer brewed with larger amounts of rice added to the grist. This would produce a beer lighter in color while giving it a more delicate body, similar to current mass-produced pilsner-style beers. The hope might have been to sell this as a lower-alcohol beer. Rice beer was one of two beers that were being marketed as nonintoxicating beverages. If they were not intoxicating, then they would fall outside the prohibition law.

The second beer or beer-like beverage to debut during Fulton County's early dry years was New Era Beer. This nonalcoholic beer was first manufactured in Kenosha, Wisconsin, in 1882 by the New Era Brewing Company. In February 1887, a court case involving P.J. Kenny alleged that he was selling intoxicating beer in his saloon. The beverage in question was New Era Beer. Ultimately, the case was dismissed because the jury could not conclusively determine whether New Era was intoxicating. The largest Atlanta court case dealing with New Era was *Connolly v. the City of Atlanta.* In this case, it was determined that a liquid sold under the name New Era (but perhaps not actually New Era) was intoxicating. However, the case determined that New Era *itself* was "not conclusively nonintoxicating."

Another beverage in P.J. Kenny's case and other prohibition cases in Atlanta was Agaric. This beverage served for all practical purposes as "near whiskey." Other street names for this dubious elixir were Nerve Tonic and Old Gary. Old documents show that Agaric was originally a form of liqueur or bitters used to flavor cocktails. This compound may have contained an extract of a particular fungus (agaric mushrooms). A large batch of the Agaric flavoring compound was purchased by an Atlanta mixologist prior to the 1880s prohibition period. It never caught on and was put in storage. During the prohibition period, this compound resurfaced as a drink.

Apparently, the original Agaric was mixed with watered-down rye whiskey to produce a supposed nonintoxicating elixir or "stimulating nerve tonic." This beverage was sold as a substitute for standard whiskey and seems to

have been helpful in getting rid of fungus overstock. It was most often sold under the names Agaric or Southern Nerve Tonic. Records hint that the effects on people could be rather dramatic. We wonder whether imbibers were inebriated by the whiskey or were instead tripping on compounds from the mushrooms.

Very often, nonalcoholic drinks (truly nonalcoholic beer, soda water mixtures or fruit juices) were spiked with alcohol upon a signaled request from a regular or by gaining the trust of certain barkeeps. As noted by Hammond Moore in *South Atlantic Quarterly*, "Go into a wine room…and ask for New Era Beer and wink your left eye, you get regular lager." If the nonalcoholic beverage was corked, alcohol could be added via syringe stuck through the cork. A patron in the know could then be safely observed by authorities or Drys uncorking a bottle clearly labeled with a nonalcoholic brand name yet partaking on the sly.

## MEDICINAL ALCOHOL AND PATENT MEDICINE

During this early prohibition period, druggists could legally prescribe alcohol to patients. Alcohol had long been used in medicine, most often for relief from pain. Another method was through patent medicine, which often contained significant amounts of alcohol. The author of *Fizz* notes, "Postbellum Atlanta was the national capital of patent medicine, packing in more quacks per head than any other US city." Atlantans took patent medicine for everything from childbirth to headaches to liver cleansing.

One noted local patent medicine experimenter and druggist was John Pemberton. He was gaining some success in Atlanta with his French Wine Coca, released in 1884. In advertisements for the compound, he listed a plethora of illnesses it could cure. French Wine Coca was based on a successful European tonic—Vin Mariani—a wine infused with coca extract (cocaine). With the Fulton County local option law in effect, Pemberton's French Wine Coca may have been safe for a while since it was wine, and at this time cocaine was legal. But the label "French Wine" could have been problematic. Under Fulton County local option, only domestic wine was allowed. This may have caused him to explore another drink to carry some of the desired ingredients.

Using any alcoholic beverage would have been risky since the temperance movement had already proven its power by convincing Fulton County (and thus Atlanta) to vote itself dry. Pemberton began developing a temperance-

HEALTHY DIGESTION.
—
A Clear Complexion.
—
BRIGHT EYES.

PEMBERTONS
FRENCH WINE COCA.

ERYTHROXYLON COCA PLANT.

A happy and contented state of the mind, buoyant spirit, an elastic step is the dearest wish of the Invalid and Dyspeptic, and those suffering from Nervous Prostration. No other tonic will so certainly and promptly bring about these results as

PEMBERTON'S
French Wine Coca.

An October 1885 advertisement for John Pemberton's French Wine Coca in the *Atlanta Constitution. Courtesy of www.Fold3.com.*

safe soda fountain syrup based on his coca extract formula that had made French Wine Coca a success. Soda fountain syrup would tap into the popularity of flavored carbonated soda drinks. Cola nut extract was also gaining popularity as a wonder drug in the 1880s. Pemberton mixed these two popular concepts in developing a coca extract and cola nut soda fountain syrup. The bitterness of the cola nut was offset by a hearty dose of sugar. In May 1886, a business partner of Pemberton's coined a term from the new soda fountain syrup; he suggested Coca-Cola. (Lest this cause you any concern, we will add that cocaine was replaced by caffeine in 1903.)

Atlanta in 1887 had witnessed sweeping alcohol legislation, quasi-legal and illegal sales, mass transportation of alcohol, the advent of temperance beverages and a multitude of arrests and convictions. In all the excitement over wine rooms, blind tigers and jug trains, Atlanta had quickly arrived at another crucial juncture. By the terms of local option, it was again time to vote.

# Chapter 4

# FROM WET ATLANTA
# TO DRY GEORGIA

*John Barleycorn in Georgia is dead, and the rest of the country wants
the same sort of prohibition.*
—*Reverend Dr. Len G. Broughton,* Atlanta Constitution, *1907*

On November 10, 1887, an *Atlanta Constitution* notice appealed to "every
citizen of Atlanta, white and colored who prizes his liberty and the
prosperity of Atlanta." The struggle was on again to determine whether
Fulton County was to be wet or dry. The campaign was just as lively as the
1885 local option election. However, this time the Wets were on the offensive.
They were better organized as they prepared for the two-year election.

The wet platform learned to successfully use the Drys' claims against
them. The Wets claimed the Drys were disrespectful of the working class
of Atlanta. The Drys had insisted prior to 1885 that prohibition allowed
the working class to buy more furniture, food and fuel for their families
since their money was not being spent on alcohol. The Wets declared that
this statement proved the prohibitionists looked at the working class as
sots, paupers and beggars. The Wets went on to point out that the upper-
and middle-class people claiming to be dry could easily deny a luxury to
the working class since the better-off had access to jug train orders and
private clubs.

Wets rallied against the Atlanta Police's enforcement practices. They
maintained that the act of shooting at people merely because they had
bought liquor was an outrage. Where was the personal liberty for the

working class? This struck a chord with Atlanta's labor class of all races. The whole concept of prohibition, they maintained, smacked of classism.

As in the 1885 election, the African American vote was critical to a local option victory. Again, both Drys and Wets focused on securing the black vote. In November 1887, a hugely popular traveling patent medicine salesman named Yellowstone Kit became important in the local option campaign. Kit was a black gentleman of small stature who projected a booming and charismatic voice. People of all races would stop to hear him speak at the corner of Loyd (now Central Avenue) and Hunter Streets.

Patent medicine was quite popular during this period, and the best way to advertise in a pre-radio world was the traveling show. Yellowstone Kit's lectures were part of his patent medicine show that promoted his products. He was, from all appearances, one of the best salesmen of patent medicines in the Southeast. He was especially popular among Atlanta's African American population. When Kit threw his support behind the Wet campaign, it helped solidify the anti-prohibition vote.

Once more, Atlanta's streets were filled with parades and people wearing red and blue to symbolize their support for each cause. Massive rallies were held, and the voter registration was even higher than in 1885. The night before the vote, fifteen thousand people crowded Marietta Street as part of an anti-prohibition rally.

Voting day—November 26, 1887—again saw WCTU members preparing lunches for midday voters. This time, anti-prohibition women also used this strategy. The presence of women who were against prohibition was a bit of a shock to Fulton County Drys, especially WCTU representatives.

The poll results were different: Fulton County voted to return the sale of beverage alcohol. "It is Wet," declared the *Atlanta Constitution* the next day. The article continued, "Fulton County Overwhelmingly Decides Against Prohibition, the Dry Side Carries Only One of the Sixteen Precincts, Everybody in Good Humor."

Alas, not everyone was in good humor. The prohibition leaders were quick to blame Atlanta's African American population for their loss. Author David Ruth sums up this point in *The Georgia Prohibition Act of 1907*: "Prohibitionists blamed the black voter for defeat in Atlanta, and, from then on, Drys myopically saw blacks as drunkards and as willing dupes of the liquor forces."

The Drys attempted to overturn this vote at every opportunity through the remainder of the nineteenth century. In the 1891 popular vote for local option, the wet "citizens' ticket" triumphed over the dry "anti-barroom"

ticket. Several minor fights broke out near polling stations. According to the local newspapers, a number of ballots were turned in bearing the phrases "run the fanatics out" and "enough of Sam Small." Fulton County (via the population of Atlanta) had firmly become wet territory. This was not unusual, as Georgia counties with the largest cities tended to remain wet.

## THE BIRTH OF PROHIBITION PRESSURE POLITICS

Cities were wet, but counties without significant urban areas were quickly becoming dry under local option. The women of the WCTU conducted highly organized campaigns throughout the state. When moral suasion failed to get a county to vote dry, the WCTU would hold rallies at the polling stations. Its members would directly question voters about their voting intent as they walked toward the ballot box. Cheers would ring out if they were dry voters. Conversely,

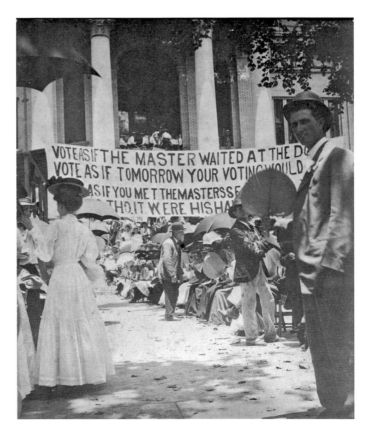

A temperance crowd at a local option vote, showing the "gauntlet" citizens had to walk through to vote on prohibition. *Georgia Archives, Vanishing Georgia Collection, image number low104.*

wet voters were jeered and heckled. Lines of children formed around the ballot boxes holding banners proclaiming, "Vote for Us." The Drys let the Wets know, in no uncertain terms, that they were anti-family, anti-establishment and sinful. In Cartersville, a large picture of Reverend Jones hung above the ballot box. Wet voters had to run the gauntlet to vote against local option, and many chose not to due to immense social pressure.

Despite successes of the WCTU and other temperance organizations, the inability to completely dry out Georgia agitated the prohibitionists. Another temperance organization was growing rapidly and would enter the Georgia prohibition battle. It used the existing church network, modern business practices, political pressure and "social media" of the time to pursue its goals. It would, arguably, become the most powerful lobbying group in American history.

## Formation of the Anti-Saloon League

The beginnings of the Anti-Saloon League of America (ASL) can be traced to Oberlin, Ohio, where a state temperance organization was formed in 1893. The Ohio Anti-Saloon League worked to strengthen the state's existing alcohol laws, to unify temperance-minded people and to strengthen legal restrictions. Instead of focusing on alcohol in general,

The Anti-Saloon League's Lincoln-Lee Legion abstinence pledge for children. Lee was invoked to make it more appealing to southern parents. *Collection of Ron Smith.*

the Ohio ASL targeted the saloon, the greatest retailer of alcohol to the public. Under the leadership of Reverend Howard Hyde Russell, a long-term anti-alcohol activist, the organization spread its message through the social network of city and small-town churches.

Being interdenominational and bipartisan, the Ohio ASL reached to every small town, prompting all churches to go on the defense against the local saloons and donate back to the Ohio ASL. The organization then used the income to print more literature and send their agents to garner support from less-supportive areas of the state.

In 1895, the Ohio ASL merged with another temperance organization in Washington, D.C., to become the National Anti-Saloon League. This national league evolved into the Anti-Saloon League of America. Although struggling in its early years, the ASL spread from state to state becoming the country's most powerful temperance force. The ASL published the *American Issue*, the *Anti-Saloon League Yearbook* and a host of other media. At one point, its publishing branch, the American Issue Publishing House, produced more than forty tons of anti-liquor publications each month!

## The Georgia Anti-Saloon League

In 1906, the newly formed Georgia Anti-Saloon League held a large rally hosted by the famous circuit preacher Reverend Sam Jones at Atlanta's Bijou Theater. The event was listed in newspapers as the first meeting of the Georgia branch of the ASL. Reverend Solomon was noted as the Georgia ASL superintendent.

Another prominent Georgia ASL officer was future congressman and U.S. presidential candidate William Upshaw, who served as vice-president of the newly formed organization. Upshaw was a WCTU supporter and believed that women had prepared the way for the work of the Georgia ASL. He was a fiery public speaker, and his ardent support of prohibition also gained him the nickname "the driest of the Drys." Upshaw spent the majority of his early adulthood in rural Cobb County writing for the Atlanta periodical *Sunny South* and later published the weekly paper *Golden Age*. At the age of eighteen, he suffered an injury that would leave him on crutches for the balance of his life. Upshaw frequently guest lectured for Georgia ASL and WCTU gatherings, and his involvement in these organizations likely strengthened the bond of Georgia's two powerful temperance organizations.

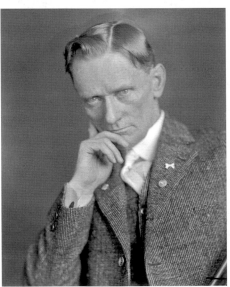

The Georgia ASL expanded its reach, hosting frequent rallies aimed at specific legislative goals. In September 1906, the group began production of a monthly paper entitled the *Georgia Issue*. Using the model developed by the national organization, the two state superintendents canvassed the state. These men were well paid for their efforts, as the bulk of the Georgia ASL's budget went toward the state superintendents and other high-profile speakers.

By early 1907, the Georgia ASL reported that local leagues had been established in just over one-third of Georgia's counties. *Laughter in the Amen Corner*, a book that details the life of Reverend Sam Jones, captures the essence of the ASL platform: "In every lecture, circular, and newspaper article, the saloon was made to seem 'the source of all misery and vice.' 'Liquor is responsible for 19% of the divorces, 25% of the poverty, 25% of the insanity, 37% of the pauperism, 45% of

*Top*: Reverend J.C. Solomon, superintendent of the Georgia Anti-Saloon League. *The Passing of the Saloon*, 1908. *Collection of Ron Smith.*

*Left*: Congressman William Upshaw, a powerful lobbyist and politician in the Georgia state and national Prohibition movements. Note the WCTU pin on his lapel. *Library of Congress.*

Atlanta's Flatiron Building (English-American Building). In 1919, the Georgia Anti-Saloon League maintained its headquarters on the eighth floor. *Ron Smith*.

A button from the 1910 Anti-Saloon League Convention. *Photo by Bob Toney.*

child desertion, and 50% of the crime in this country.'" If the saloon went away, the ASL reasoned, the collective cost of running asylums, jails and orphanages would be dramatically reduced.

The dry platform (with the aid of the Georgia ASL) had achieved a dry state with the exception of fewer than twenty counties. While the WCTU continued to focus on local option, the ASL determined that this technique was not successful, as wet Georgia counties were still supplying the dry ones via jug train.

## The Wet Perspective

While the Drys were working to outlaw beverage alcohol statewide, the industry itself had resumed day-to-day business operations. The rising cost of city, county, state and federal taxes and licensing put additional

burdens on Atlanta's wholesalers, restaurants, saloon owners and breweries. Politicians gave a sympathetic ear to Drys, agreeing that license fees needed to be increased to control this vice. In turn, the increase in city revenues from license fees aided in building Atlanta's infrastructure and winning popularity for the politicians—from both Wets and Drys.

Collective organization had helped the Wets win the Fulton County local option in 1887 and hold onto that victory through a series of reelections into the early twentieth century. If the higher level of organization among the Atlanta Wets continued, it was accomplished with less publicity than that of the Drys' campaign. The Wets overwhelmingly held a sense of distrust and sometimes outright hatred for Drys. Their businesses had been hurt not only by increasing social scorn propagated by the prohibitionists but also by legislation championed by the Drys. It is worth noting that the Drys did not openly attack the families of the Wets since their platform was based on family values. Only the business owners and physical businesses were portrayed as "agents of evil."

In 1899, Atlanta's brewery (now called the Atlanta Brewing and Ice Company) warned the *American Brewers' Review*, "Gentlemen...we think it is a good idea to abandon the publication of the output of breweries in your annual Brewers' Guide." This caution is clearly in response to the Drys' tactic of using brewery statistics to promote their cause. The change in the company's name in 1891 may also have been in response to the shifting sentiment. The brewery was producing a large amount of

The Atlanta Brewing and Ice Company, circa 1900. *Courtesy of Kenan Research Center at the Atlanta History Center.*

ice that could be sold independent of brewery operation and sales if the need suddenly arose.

The *Year Book of the United States Brewers' Association for 1910* reflects the Wets' perspective: "Men will never be legislated into real morality, and, in pinning so much faith and value to law as a moral reformer, the prohibitionist is evidencing a decided weakness of his system." This growing tension would be escalated as the Drys set their sights on a larger target: that of state prohibition.

## THE ROOTS OF STATE PROHIBITION

State prohibition was not a new concept; the infamous Maine Law (1846–1851) was a benchmark for prohibitionists. In Georgia, the Drys were aware of the long temperance history of the state and took it as a sign of the righteousness of their cause. The vast majority of the state was already dry via local option. Yet to gain control over the beverage alcohol industry, the Drys needed a bill that consolidated, strengthened and in many cases superseded Georgia's current prohibition regulations.

Their first attempt came in 1899 in the form of the Willingham Temperance Bill. For over a month, the bill was debated, leading to a Georgia House of Representatives vote on November 22. The measure passed the house but did not fare as well in the Georgia senate. In December of the same year, they killed the bill by a vote of twenty-six to fourteen.

It would be nearly six years before a similar measure would grace the Georgia legislature. A second state prohibition bill was introduced in July 1905. Evidence suggests this bill was modified away from state prohibition to become a proposed massive state liquor license increase of 400 percent (from $200 to $1,000, or approximately $5,100 to $25,500 in 2015 dollars) for private businesses and state dispensaries.

The journal article "Alcoholic Beverage Control Before Repeal" brings up an interesting fact: "Government monopoly of the sale of liquor for general consumption originated in the United States in the college town of Athens, Georgia in 1891." The concept of state dispensaries is that the state is the only legal authority to sell beverage alcohol within a certain county or city, with no other retailers or wholesalers allowed in that territory. Drys were split on their opinion of state-run dispensaries. Some, like Seaborn Wright, viewed it as a better alternative than the saloon. Others saw it as the State of Georgia legitimizing the sale of alcohol.

*Puck* magazine's January 15, 1908 cover illustrating a humorous view of prohibitionists marching through Georgia. *Collection of Ron Smith.*

Drys were making better legal progress in the state, but try as they might, they could not grasp the golden ring of state prohibition. In September 1906, though, Atlanta would hand them the means by which they would obtain their goal.

## 1906 Race Riot

In the hotly debated Georgia governor's race of 1906, both candidates were running on platforms designed to disenfranchise minorities, specifically African Americans. In the 1885–87 Fulton County local option vote, the electorate had solicited the black vote. In the early 1900s, it was the opposite—each candidate sought to suppress that vote as a means of victory. Both sides used yellow journalism, racial fears and hysteria to support their platforms. Taking cues from race baiting in other parts of the nation, the factions focused their rhetoric on the integrated nature of Decatur Street, especially the saloons. This negative journalism introduced the first common usage of the term "dive" in Atlanta, describing a lower class of social institution or saloon.

In their quest for sensationalism, Atlanta newspapers published unverified stories of black assaults on white women to gain headlines. The volatile combination of these accusations, white male drinking patterns, social frustrations and political antagonism exploded into one of Atlanta's darkest episodes: the Atlanta Race Riot of 1906.

On September 22, in the late afternoon, a mob of between five thousand and ten thousand whites went on a violent and destructive rampage. Exactly how many people were killed and wounded during the four days of violence is uncertain. According to *Religious Leaders in the Aftermath of Atlanta's 1906 Race Riot*, "The city coroner issued only ten death certificates for black victims, but estimates from other sources range from twenty to forty-seven African-American deaths, one hundred fifty critically injured, and countless others who fled the city." Most sources agree that only two whites were killed, one being a woman who suffered a heart attack after witnessing the mob outside her home. Considerable property damage and theft were also reported.

The *Atlanta Constitution* quoted Reverend Jones, speaking at a revival meeting the next day, as proclaiming, "You may say that the bloodshed in Atlanta last night was inevitable, but whiskey, yes, whiskey, was behind it. I want to see those disgraceful Decatur Street dives of debauchery and sin obliterated." His sermon continued by focusing on personal certainty that

alcohol was involved in the assaults on white women and that the black saloons on Decatur Street needed to be closed. Jones chose not to address the violence of the white mob. This extremely myopic view of the riot was taken up by many Atlanta newspapers, political leaders and local clergymen. Precious few acknowledged the fact that the mob was Anglo American and did not originate from the Decatur Street dives.

Atlanta's image as a model city of the New South was shattered. The city was featured unfavorably in national press, as well as in international coverage. City leaders were under pressure to remedy the origins of this violence. The Evangelical prohibitionists, most notably the Georgia ASL, proclaimed that the obvious explanation was that the saloon was the root of this evil. Only one white minister, Gary Wilmer of St. Luke's Episcopal Church, took a different approach by arguing, "It is quite possible to be led astray and make a scapegoat of liquor as if that were the sole or even the chief cause of the late riot." Reverend Wilmer put the blame on flaws in the human heart.

This reasoning did not come into play as the city council began a campaign to close ill-reputed businesses on Decatur Street. The mayor ordered all saloons in the city closed and had each owner reapply for a license so the city could weed out the dives from the reputable businesses.

## Hardman-Covington-Neal Seals the Deal

In October 1906, the *Atlanta Constitution* reported that thirty-six Atlanta whiskey and beer saloons had been closed, and the pressure was on to close more. No new racially integrated saloons were allowed; as licenses expired, existing saloons were pressured to become either "colored only" or "white only." No chairs or tables were allowed in saloons, and people who stayed beyond a few drinks could be arrested for loitering. Georgia's largest wet city had obviously changed since the riot, and the Drys, back on the offensive, made sure it stayed that way.

The women of the WCTU were frequently seen in the Georgia State Capitol serving lunch and refreshments to state legislators. Although unable to vote, this gave them an opportunity to talk directly with lawmakers. Free food kept the politicians nearby long enough to engage them in conversation and to offer them a white ribbon or WCTU leaflet about prohibition. Behind the scenes, the Georgia ASL met with politicians. The message conveyed was that the voting network of thousands of Georgia churches was with or against

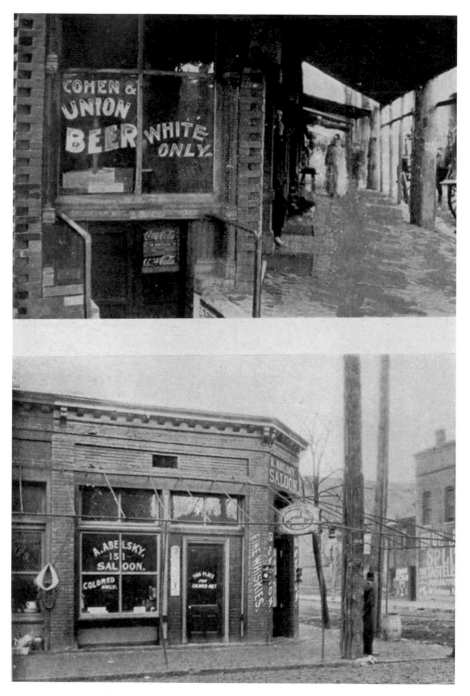

Racially segregated Atlanta saloons. *Photographs from* Following the Color Line, *by Ray Baker (Doubleday, Page & Co., 1908).*

them depending on how they voted. The de facto leader of the Anti-Saloon League of America, Wayne Wheeler, was once quoted as saying, "I don't care how a man drinks; I care how he votes."

Politicians were not the only people to vote dry but live wet. Many southerners drank alcohol yet voted to keep liquor out of the hands of others whom they feared would abuse the substance to the detriment of society. People who followed this double standard were often called "Wet Drys." While the WCTU worried most for an individual's morals, the ASL worried over votes first and morals later. These two organizations—backed by other temperance groups and fraternal societies—composed the heart of dry lobbying.

The WCTU water fountain placed in the Georgia State Capitol in commemoration of noted member and women's suffrage advocate Mary L. McLendon. *Ron Smith.*

In July 1907, a third attempt at state prohibition began. Dubbed the Hardman-Covington-Neal Bill, the legislation was immediately filibustered in the Georgia House of Representatives by the Wets for an entire week. On the night of July 25, the session had been going for over thirteen hours in a long and miserably hot day of filibustering. The sweltering gallery was packed elbow to elbow with Wets and Drys. A large contingent of WCTU women was in attendance, including Mary Harris Armor, president of the Georgia WCTU. The frustrated Drys began cheering the legislators on their side. An outburst from Seaborn Wright, the leading dry representative, denounced the filibuster and brought more disruption from the gallery. The speaker pounded his gavel and ordered the gallery cleared by the police.

Mary Harris Armor of the Georgia WCTU. The passing of the 1907 state prohibition law is credited to her lobbying. *The Passing of the Saloon*, 1908. *Collection of Ron Smith.*

As the police emptied the gallery, women hissed and men yelled curses. The *Atlanta Constitution* reports that some called for the speaker to come up to the gallery so they could throw him over the banister. Once the gallery was cleared and order restored, the voices of the yelling Drys could be heard through the doors. Wet representative Joe Hall stood and condemned the continued disruption. Seaborn Wright interrupted him, and Hall shot back that after having just caused the gallery to be cleared, he was surprised Wright was yet again agitating the discussion. More words were exchanged, and Wright called Hall a liar. According to several sources, this last exchange prompted a fistfight and a twenty-minute ruckus among the legislators. The house was adjourned until the next day, when, in a closed session, state representatives finally voted 139 to 39 to pass the bill. The Drys massed in the capitol burst from the building singing hymns and formed a spontaneous parade of thousands in Atlanta's streets.

Governor Hoke Smith set his signature to the Hardman-Covington-Neal Prohibition Bill on August 6, 1907, before the bill's sponsors, J.B. Richards of the Georgia ASL and over three hundred Drys bearing witness. Once his signature was added, a cheer went up and the prohibitionists broke out in a hymn. State of Georgia beverage alcohol sellers had less than four months to prepare for state prohibition.

Ironically, by signing the prohibition bill, Governor Smith lost some of his annual income. He owned a one-third interest in the Piedmont Hotel. The hotel operated a bar most commonly known as the Gal in the Fountain. This unique name was derived from the fountain in the center of the barroom, which

featured a bronze statue of a nude lady wreathed in grapes. During the prohibition campaign, Hoke was ridiculed by both sides for his ownership in the bar while supporting state prohibition. In reference to the governor, this statue was jokingly called the "Cracker Venus" wreathed in "Georgia muscadines."

By December, Atlanta newspaper ads announced "The Last of the Liquor." A detailed *Atlanta Constitution* article listed the businesses that would be affected by the prohibition law: eighty-six whiskey saloons, twenty-three beer saloons, twenty-one wholesale liquor houses, two wholesale beer houses and one brewery. The same article estimated the city's loss of revenue to be over $131,000 in license fees, a substantial $3.3 million loss of revenue when adjusted for inflation to current dollars.

On the eve of 1908, the night before the Hardman-Covington-Neal Prohibition Bill went into effect, the Drys held watch-night services at the Baptist Tabernacle

Seaborn Wright

*Famous Georgian Orator Speaker at "Dry" Meeting Tonight.*

*Top*: Seaborn Wright, a Georgia dry legislator, was famous not only for oration but also for his part in a fistfight in the Georgia House of Representatives. *Courtesy of Dona Patrick.*

*Right*: J.B. Richards, associate superintendent of the Georgia Anti-Saloon League. *The Passing of the Saloon,* 1908. *Collection of Ron Smith.*

*Left*: Governor Hoke Smith, signer of the 1907 Georgia state prohibition bill. *The Passing of the Saloon*, 1908. *Collection of Ron Smith.*

*Below*: The Tabernacle, Atlanta. Throughout most of its history, it would be a prohibition stronghold. Ironically, it later became a concert venue that serves alcohol. *Ron Smith.*

(likely the Third Baptist Church) and the Wesley Memorial Chapel. Reverend Broughton (who was commissioning the new Tabernacle on Luckie Street), Seaborn Wright and a representative of the ASL gave speeches. As midnight approached, church bells rang out, and Drys cheered. The golden pen Governor Smith used to sign the bill was prominently displayed. At the stroke of midnight, Broughton broke a bottle of whiskey to signify the passing of King Alcohol from the state.

In the early 1900s, alcohol was typically personified in song, poetry or illustrations as one of two entities: King Alcohol or John Barleycorn. King Alcohol was often portrayed as a rotund crowned white man with a beer mug in hand (Gambrinus) or sometimes by Drys as a crowned skeleton or

The December 1907 *Atlanta Constitution* showing whiskey leaving Atlanta due to state prohibition. The term "salt river" was an expression for defeat. *Courtesy of www.Fold3.com.*

demon. John Barleycorn was portrayed as varying characters, often Celtic, or as an animated liquor bottle.

In John Barleycorn's Atlanta habitat, the eve of state prohibition was mostly uneventful. The wholesalers were making brisk sales as people stocked up for dry times. Women ordered from their buggies, having loads brought out to the carriages to take back home. The saloons were busy yet orderly and closed at ten o'clock at night, as required by city ordinance. Newspaper reporters commented on just how typical and anticlimactic the night was. This evidence leads one to wonder how anti-society these businesses actually were. Regardless, at the stroke of midnight, Georgia became the first dry southern state.

## Chapter 5

# THE EFFECTS OF
# STATE PROHIBITION

*Where are the near beer dealers,*
*What has become of their coin?*
*They're hiding from the revenue club,*
*The state urged them to join.*
—Atlanta Constitution, *October 4, 1908*

Thus were presented the opening lines of the Hardman-Covington-Neal
Prohibition Bill (aka the State Prohibition Act of 1907):

*An act to prohibit the manufacture, sale, barter, giving away to induce trade,*
*or keeping or furnishing at public places, or keeping on hand at places of*
*business of any alcoholic, spirituous, malt or intoxicating bitters, or other*
*drinks, which if drunk to excess will produce intoxication...*

The act included amendments for pure alcohol to be used for medical
purposes, with a written prescription provided by a doctor and filled by a
druggist. Various types of alcohol for industrial manufacturing, medical
research and scientific purposes were also allowed.

The Drys congratulated themselves on the state prohibition victory and
comprehensive restrictions in the language of the law. However, the line
"drinks, which if drunk to excess will produce intoxication," would come back
to haunt them. Another wild card in state prohibition was federal liquor law.
United States Revenue officials were operating at the federal level, still collecting

federal alcohol taxes via a federal license regardless of state law. At the time state prohibition was voted in, there were approximately 1,200 federal liquor tax permits in Georgia. Under state law, only druggists, makers of medicinal or industrial alcohol and wholesalers of medicinal or industrial alcohol could operate and be taxed. This would be only the beginning of alcohol conflicts between Georgia and the federal government.

## THE RETURN OF THE BLIND TIGER

Cases involving blind tigers started the first day of state prohibition. In February 1908, five men were arrested in the Virginia Hotel on Broad Street for running a blind tiger. A Baptist minister procured the evidence and tipped off the police to the operation. Atlanta's most noted Baptist minister, Reverend Broughton, gave his opinion on blind tigers, whiskey sales and the legal system in an *Atlanta Constitution* quote: "[Blind Tigers] must be outlawed and the doctors [selling medicinal whiskey] in collusion must be branded with murder…if the courts are not going to do this…then let them get out of the way, and give us a chance to put men in who will do it."

For a short period, overall arrests dealing with alcohol actually decreased—seemingly while citizens of Atlanta learned the ropes of the blind tiger trade. Soon enough, arrests of "walking blind tigers" were fairly common in the city. A walking blind tiger sold liquor in small quantities (flask or by the drink) on foot or from a moving wagon. Sometimes the drink was a swig straight out of the bottle. In other instances, the tiger had an overcoat with an elaborate tube system to dispense liquor into a passing customer's waiting glass. The exchange might look like someone asking for directions or chatting about the weather.

A blind tiger within a residence on Ivy Street (now Peachtree Center Avenue) was also operating using rubber tubing. The owner would use a removable pump to bring whiskey up from barrels buried in the building's

*Opposite, top*: A blind tiger drawing from the September 1911 *Atlanta Constitution*; however, the tigers were not under such good control. *Courtesy of www.Fold3.com.*

*Opposite, bottom*: A "roving tiger" in the form of a moonshine-dispensing wagon. *Atlanta Constitution*, December 1909. *Courtesy of www.Fold3.com.*

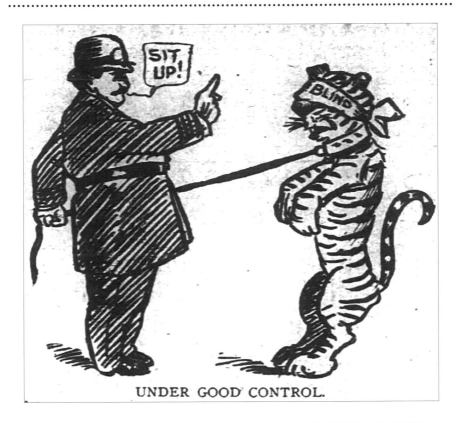

UNDER GOOD CONTROL.

## OLD "PRAIRIE SCHOONER" TYPE OF WAGON PROVES TO BE VERY LIVE BLIND TIGER

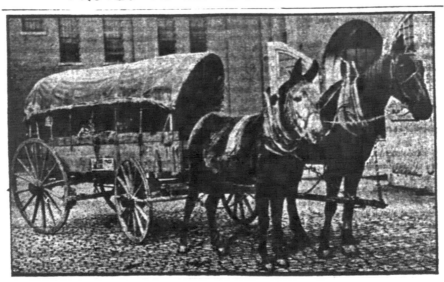

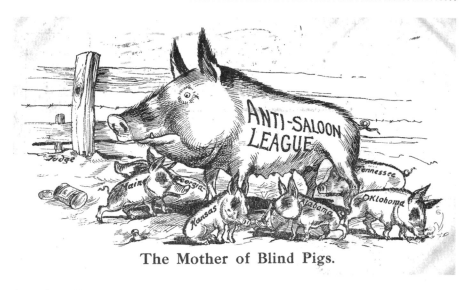

The Mother of Blind Pigs.

An anti-prohibition postcard blaming the Anti-Saloon League for the creation and persistence of blind pigs (tigers). Drawing by Judge, postmarked 1910. *Collection of Ron Smith.*

cellar. When the police stopped by to inspect the house, the whiskey on hand was quickly dumped into a barrel of water. Atlanta's city police were, from the start, hard pressed to keep up with the growing number of blind tigers and their increasing obscurity.

On a Saturday in mid-August, the Atlanta police discovered a "blind tiger of superior growth" operating in the Georgia State Capitol building, according to the *Year Book of the United States Brewers' Association for 1910* and several other historical and contemporary sources. This fact came as a shock to Georgia citizens, both Wets and Drys. Although the illegal distributor was taken into custody, his clientele was never mentioned.

To combat the ever-increasing wariness of blind tigers, by 1909 the police were using informants and marked money to prove blind tiger transactions. A bizarre *Atlanta Constitution* article appearing in May of the same year hints at the frustration dry-minded Atlanta citizens must have felt toward blind tigers. In the article, the mayor briefly considered the use of a lady detective from New Orleans who hunted illegal alcohol sellers with a pack of bloodhounds.

## THE JUG TRAIN ROLLS AGAIN

With the dawn of state prohibition in 1908, the Georgia wet-to-dry-county jug train switched to interstate business. The Atlanta whiskey distillers, wholesalers and rectifiers (people who take whiskey distilled by others and blend it for final consumption) packed up their shops and headed to the wet

## "YOU BET WE'RE WET!"

State prohibition forced Georgia distillers to move operations to Chattanooga, Tennessee, and Jacksonville, Florida, boosting those cities' economies. *Atlanta Constitution*, June 1908. *Courtesy of www.Fold3.com.*

states bordering Georgia. The largest concentration of these dealers was just across the northern border in Chattanooga, Tennessee. Wholesalers like I.H. Oppenheim, located on East Alabama Street in downtown Atlanta, moved to Chattanooga and ran ads in Atlanta newspapers stating, "Fifteen years in Atlanta—send your orders now to Chattanooga."

A buyer would send money by mail order to the Chattanooga distiller or wholesaler. Upon receipt of the funds (transaction completed in the wet state of Tennessee), the package would be placed on the next train for Atlanta. Since the package was purchased out of state, the transaction was legal on both sides. Newspaper ads urged Atlanta buyers to avoid blind tigers with their questionable and illegal products. Instead, consumers could buy from former Atlanta businesses. The wet states, notably Florida and Tennessee, were more than happy to receive the sudden rush of income from alcohol licenses and other business taxes associated with the new trade.

*Putnam's Monthly and the Reader* explained the "lightning express" or the "Chattanooga express." This illegal extension of the jug train phenomenon was a system whereby an Atlanta buyer paid a runner some money and thirty minutes later a parcel arrived stamped from Chattanooga and delivered addressed to the named payee. This process must have relied on a rather fast train (ahem) considering that Chattanooga is almost 120 miles from the city.

## LOCKER CLUBS

In the first month of state prohibition, a committee of Atlanta councilmen and police toured the city's private clubs that contained locked individual liquor cabinets to look for any prohibition violations. This private club liquor cabinet arrangement was commonly known as a "locker club." A good-standing, dues-paying member of a specific club could pay to have his own private liquor locker in which to keep a personal supply to drink and treat other members of the club or registered visitors in the socializing area. In the early 1900s, Atlanta had approximately twenty private clubs, fraternal orders and societies that contained locker clubs. At least two of these 1900s private clubs—the Capitol City Club and the Transportation Club—still exist today.

The committee was satisfied that the prohibition law was being upheld. Arguments abounded about the need for locker clubs to pay the federal liquor tax and the nature of visitors. If a private club had visitors, did

*Right*: Candler Building, Atlanta. In 1916, the top floor was occupied by the Mechanics & Manufacturers Club, which contained a locker club. *Ron Smith.*

*Below*: The interior of an early 1900s Atlanta locker club based on a period advertisement, furnishings and clothing. Drawing by Rose Dunning, 2015. *Courtesy of Rose Dunning.*

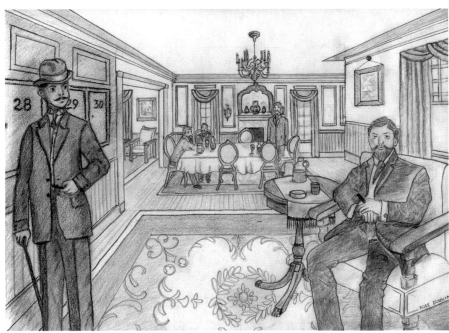

that make it a public space that therefore fell under the state prohibition law? Initially, few arguments against locker clubs were heard in Atlanta. One explanation for this silence could be that the local lawmakers were prominent private club men.

## NEAR BEER, ATLANTA'S NEWEST "PROHIBITION BEVERAGE"

In the fall of 1907 as the deadline for state prohibition approached, the dry counties of Georgia saw a new beverage catch headlines as "near beer" entered the scene. Touted as a nonintoxicating variety of the ever-popular lager beer, what exactly this beverage was and how to regulate it baffled not only police but also the entire legal system. Once state prohibition was in effect, several 1908 blind tiger cases were settled using a key phrase within the state prohibition act: "drinks, which if drunk to excess will produce intoxication." This strict interpretation of the law gave former beverage alcohol sellers enough of a loophole to try their luck with near beer. Thus, the near beer saloon made its appearance in the city of Atlanta and quickly became popular.

The prohibition leaders and Drys of Atlanta became alarmed that near beer was not regulated as an illegal alcoholic beverage. One councilman was stunned that the number of saloons was on the rise. This new beverage could be sold like tea or any other soft drink, even at soda fountains.

On May 7, 1908, a joint committee of city officials met to try to handle the near beer problem. Three women from the Frances Willard Chapter of the Atlanta WCTU were also in attendance. Although the WCTU and many others on the council wanted to simply outlaw near beer, the court had already determined that the beverage was legal under the strict definition of the law and was therefore not regulated as alcohol. A motion was also made to ban women from near beer saloons. This proposal was met by a wry counterproposal from a councilman that the ladies must be provided rocking chairs in all such saloons.

It would take weeks of continuous debate to develop an ordinance on near beer. In the city ordinance, several near beer beverages were called out by name: Malt Mead, Acme Brew (from the Macon, Georgia brewery), Red Buck Ale (Richmond, Virginia) and the Atlanta Brewing and Ice Company's Bud. But the burning questions remained: was near beer really beer, and how much (or more accurately, how little) alcohol in a beverage rendered it nonintoxicating?

A postcard from the early 1900s expressing the Drys' view of Sunday illegal alcohol sales law enforcement. *Collection of Ron Smith.*

The new Atlanta law made selling near beer on Sundays a violation. Neither sales of the beverage to minors nor free lunches were allowed. The existing near beer saloons immediately reacted to the lunch provision of this law. Drys were upset when the saloon owners applied for city food licenses and simply sold the previously free lunches at low cost along with the near beer.

In August, the chairman of the Georgia House of Representatives proposed a near beer bill that would set the alcohol level in near beer to 1.5 percent alcohol by volume (ABV) and more than double the tax. Notably, the bill avoided increasing taxes on any other type of "soft drink." Extensive filibustering suppressed the bill until the ABV references were removed and the near beer establishments were taxed a straight $200 per year.

A Decatur Street soft drink seller would pose the first major legal challenge to the near beer law. In the same month the bill was passed, Morris Cohen was arrested and charged with selling near beer both without a license and on Sunday. He had previously applied for a license with the city and was refused. He pleaded guilty to selling near beer and took the stance that the law was unconstitutional, discriminating and partook of class legislation. He pleaded not guilty to the Sunday sales because he had a soft drink license, which allowed Sunday sales, and near beer was legally classified as a soft drink.

This would not be the only prohibition battle Cohen would fight with the city. He was later arrested for having whiskey at his store, although he contended it was being stored there for his daughter's wedding. He bitterly fought the charges all the way to federal court, ultimately giving up three years later and serving prison time.

In September 1908, ninety-nine Atlanta near beer dealers signed a petition against the tax applied on near beer. This was quickly followed by an injunction filed by 115 near beer dealers against the tax. Since the beverage was supposed to be regulated the same as other soft drinks, the wholesalers and saloonkeepers were angered that the taxes were higher on near beer.

The state was, in November 1908, facing the biggest deficit in its history, which amounted to $847,000. The lost liquor revenue was $240,000, or 28 percent of the deficit (over $6.1 million in 2015 dollars). Although Atlanta's police chief threatened prosecution, most taxes went unpaid until the early part of 1909. As 1908 ended, there were 138 near beer saloons paying $425 each in annual licenses, distributed $200 to the state, $200 to the city and $25 to the federal government. Faced with paying (under protest) back taxes from 1908 and the taxes coming due for the current year, approximately forty saloon owners could not pay the total due and closed their doors.

The 1908 annual report filed by the Atlanta city recorder stated that near beer saloons were a serious obstacle to the prohibition law, and they "dispense regular lager beer to the customers they can trust and…all of them sell intoxicating malt liquor." He advised the city council to place restrictions equal to those on the old liquor saloons. He also strongly suggested that the City of Atlanta or the State of Georgia make any drink requiring a U.S. liquor license (over one-half of 1 percent ABV) illegal by modification of the state prohibition act.

## Near Beer Finally Defined

In 1909, the Georgia Court of Appeals judicially defined near beer as "any and all of that class of malt liquors which contains so little alcohol that they will not produce intoxication, even though drunk to excess." It included all malt liquors that were not within the purview of the 1907 prohibition law. The court also emphasized the legality of the 1908 near beer tax via license. In the opinion of the court, near beer retail was a different class of business from selling drugs, soda water and similar retail sales. A new bill was passed that increased the annual tax on near beer retailers to $300 and manufacturers and wholesalers to $1,000 (put in perspective, approximately $25,000 when adjusted to 2015

dollars). Wholesalers could not sell near beer in quantities smaller than five gallons, and containers had to be stamped with the manufacturer's name.

In June 1910, Atlanta adopted an amendment that near beer could not exceed 4 percent ABV. Ironically, major name brands of contemporary mass-produced beer are generally within 1 percent ABV of 1910 Atlanta near beer. Despite the 4 percent ABV cap and a huge increase in the near beer tax, local newspapers swelled with lists of saloons submitting the required public notice for a license. Atlanta in mid-1910 had approximately 201 active licenses for the sale of near beer.

*Below*: A small sample of the hundreds of published near beer license requests in the *Atlanta Constitution*, June 2, 1910. *Courtesy of www.Fold3.com.*

WHILE TOURING THE SOUTH in 1909, President-elect Taft mentioned that he would like to sample the famed southern dish 'possum and 'taters. To throw some levity on the subject, the *Atlanta Constitution* asked its readers what the best drink was to wash down 'possum. The winners were corn liquor and persimmon beer, with the runner-up being real beer, not near beer. The famous Atlanta prohibitionist preacher Dr. Broughton was also asked this question, to which he replied, "I don't drink. Neither do I eat anything that belongs to the cat, dog or rodent families."

Taft got his wish at a lavish Atlanta banquet, where he was served the marsupial whole, dressed with potatoes and accompanied by a flagon of persimmon beer. One has to wonder if it was nonintoxicating persimmon beer.

| | |
|---|---|
| I HEREBY make application for renewal of near beer license at 59 Decatur street. C. S. Brown. | I HEREBY make application to city council for renewal of near beer license at 54 Decatur St. M. Ellman. |
| I HEREBY make application for renewal of near beer license at 69 Decatur street. C. S. Brown. | I HEREBY make application to council for renewal of near beer license at 29 Madison Ave. B. Ehrlich. |
| I HEREBY make application for renewal of near beer license at 564 Marietta street. I. C. Clark. | I HEREBY make application for renewal of near beer license at 190 Decatur st. Peter Mitchell. |
| I MAKE application to city council for a renewal of near beer license at 230 Decatur street. I. Clein. | I HEREBY make application for renewal of near beer license at 74 Decatur st. Peter Mitchell. |
| I MAKE application to city council for renewal of near beer license at 18-A Ivy street. Patrick Lyons. | I HEREBY make application for renewal of near beer license at 127 Peters street. Jake Broznack. |
| I MAKE application to city council for renewal of near beer license at 121 Peters street. Patrick Lyons. | I MAKE application to city council for renewal of near beer license at 97-99 Whitehall street. J. Cohen. |

## SACRAMENTAL WINE AND STATE PROHIBITION

The *1908 World Almanac and Encyclopedia* declared, "Georgia becomes a prohibition state on January 1, 1908, and the law is so drastic that wine cannot be used at communion services in churches." This statement was not far from the truth. The law did not address sacramental wines directly.

As early as the mid-1800s, teetotal prohibition advocates knew they had a problem on their hands, as the Bible contained numerous references to alcoholic beverages. Wine in particular had a long history of religious ceremonial usage. Throughout European history, wine and beer were made, used and distributed by the Christian church. During the formation of the U.S. temperance movement (1800s), Catholicism, Judaism, Mormonism and several Protestant faiths made and used wine.

To validate their stance on total abstinence, Evangelical Protestant scholars argued that many wines had been corrupted by the addition of brandy and that all wine of their time varied greatly from that found in the Bible. According to *Religion and Wine*, the Evangelical press argued that even occasional wine users were "morally infectious." It claimed that this bad example led other people into iniquity.

Out of this temperance quandary came the two-wine theory. The theory states that wherever the Bible recommends wine, it refers to unfermented wine (i.e. the unfermented juice of grapes), and where the Bible forbids it, the text refers to fermented wine. Although circular in thought, the Evangelical Protestant Drys adopted this doctrine, and it is still practiced today. Interestingly, the growth and sustainment of the grape juice industry—most notably by the Welch family—developed from the two-wine theory. Although the 1908 prohibition law did not address sacramental wines directly, it did not enforce any ban on preparation and use of church or temple wines in Georgia.

## THE BREAKDOWN OF WET POLITICS

Atlanta in the 1890s saw the pinnacle of wet coordination and political strength. The Wets successfully maintained Fulton County's wet status during every local option vote. A 1907 *Saturday Evening Post* stated that an agent of the Liquor Dealers Protective Association had canvassed the state, getting strong support to defeat state prohibition. It also alluded to the Wets as having a "political machine." However, the tide shifted, and Wets did not

An Atlanta Brewing and Ice Company advertisement, *Atlanta Constitution,* May 1906. Here, beer is portrayed like "liquid bread," good for the whole family. *Courtesy of www. Fold3.com.*

fulfill their mission as state prohibition was voted in. The answer for what happened seems to lie in a combination of factors.

In the late 1800s, a national battle began between whiskey rectifiers and distillers over who needed to represent and regulate the industry. The Pure Food and Drug Act of 1906 heated the argument significantly, and a three-year battle began among the whiskey interests. The conflict involved numerous state and national politicians and prompted two U.S. presidential decrees. This division could not have happened at a worse time, as dry forces were pushing for state prohibition.

The brewers became frustrated with the divisional fight among the whiskey men and took their own path. Their advertisements began touting the nutritional value of beer as "liquid bread." Nutritional value paired with low alcohol by volume allowed the industry to market beer as a temperance beverage that could be enjoyed by the whole family. Some ads took it a step further by outlining a direct contrast with whiskey. The United States Brewers' Association became the de facto national leader of the wet cause in America.

The brewing community, mostly German Americans, used its work ethic and family values as a defense against prohibition. German Americans were highly respected as an industrious part of the community in many American cities, including Atlanta. Social societies such as the Turn Verein, the German Ladies' Aid Society and the Freundschaftsbund Society commonly hosted community events. The Atlanta Turn Verein maintained a locker club on its property.

Barrooms and dining halls in the lower levels of many prominent Atlanta hotels were referred to as "rathskellers" (cellar, beer hall or restaurant of a council house), a term commonly used in Germany. This wholesome Old World association would help beer's image as a more temperate drink for a few years.

The Anti-Saloon League's campaign had been so successful that by the early 1900s, most alcohol interests (especially the wine industry) had begun to distance themselves from the saloon. This once-popular format was slowly becoming a social pariah, especially after Atlanta's race riot. This worked well for the Drys in two ways. First, it reduced the most common access to alcohol that the public had, especially the working class. Second, the Wets used social networking within the saloons in the same manner that the ASL used church social networks. By eliminating the saloon, Drys could distance voting Wets from the political network.

Dry literature indicates that Drys viewed local Wets as just another Tammany Society. The Tammany Society was New York City's infamous

An advertisement for the Ansley Hotel's rathskeller from the *1916 Atlanta City Directory*. *Collection of Ron Smith.*

wet ward-driven political machine of the time. However, our research found no overt political domination by the Wets in Atlanta. Both sides equally used money, social pressure and lobbying to gain support. Eventually, disruption of wet-owned businesses and pressure against social drinking changed public sentiment and strengthened the temperance political machine. This societal shift set the course for the future of both state and national Prohibition legislation.

## Chapter 6

# GEORGIA TIGHTENS THE
# LID ON ALCOHOL

*We have a "bone dry," air-tight, extremist of the extreme prohibition law.*
—Atlanta Constitution, *1917*

Learning from the multitude of Georgia prohibition violation court cases and lessons from ASL chapters, the legal language developed by Drys at this point was specific and restrictive. They wanted no mistakes or loopholes in future legislation. A 1915 *New York Times* article quoted a radical Georgia Dry as saying he wished "the smell of liquor illegal in Georgia."

In the summer of 1915, the Drys were doing some filibustering of their own. In the Georgia legislative session, they blocked the general appropriations bill in retaliation against the Wets, who had blocked amendments strengthening the 1907 State Prohibition Act. It is unclear how a compromise had been reached by the time the September session convened. At that time, the general appropriations bill passed quickly, and the Stovall-Hopkins-Mangham Prohibition Bill started its rounds in the state capitol.

Atlanta newspapers refer to this four-part bill as a product of the Georgia ASL. The Drys had the votes and enough support in the state house and senate to push the bill through. The Drys shot down a proposal from the Wets to allow the people of Georgia to vote before passing such a restrictive measure. On November 16, Governor Nathaniel Harris signed the sections of the bill. *A Standard History of Georgia and Georgians* notes that the governor used four pens, handing one to each named sponsor of the bill and one to the superintendent of the ASL. The bill was to go into effect on May 1, 1916.

## DRASTIC PROHIBITION

In April 1916, *Atlanta Constitution* headlines captured the approach of the newest version of state prohibition: "Drastic Prohibition Law Will Become Effective Four Weeks from Today" and "For the Third Time in Its History Atlanta Has to All Intents and Purposes Gone Dry."

As mentioned, the latest amendments to Georgia state prohibition included four major components:

- A far tighter definition of illegal alcohol in Georgia, with enhanced enforcement against blind tigers.
- An anti-shipping provision to prevent liquor from being shipped into Georgia and within the state to any place of business, including restaurants, hotels and clubs. Only private residences could receive limited liquor shipments. The responsibility of proving the shipment was going to a private residence fell on the carrier, seriously restricting the mail-order liquor trade.
- Anti-advertising provisions preventing all alcohol advertising.
- The ban of 4 percent near beer sales and locker clubs in the state.

The language of the new law was extremely tight and banned the sale, barter or gifting of "any drinks, liquors or beverages containing one-half of one percent of alcohol or more, by volume" and even banned beverages, regardless of alcohol level, that imitated alcoholic beverages. If a person were arrested trying to sell a liquid having the look, color, taste, odor and general appearance of an illegal alcoholic beverage, the burden of proof was placed on the defendant. Different from usual judicial norms, a person thought to possess alcohol was guilty until proven innocent.

Regardless of all the restrictions on alcohol sales, a private citizen could order alcohol by mail for personal consumption. No more than two quarts of whiskey or strong spirits, one gallon of wine or six gallons (forty-eight pints) of beer could be delivered from sources outside the state within a thirty-day period. The receiver could have only one of the above beverage types. The new law required Georgia citizens to file an affidavit that they were not breaking the law when signing the shipping manifest and that they were not drunkards. Failure to sign properly or giving false information could result in a prison sentence.

These alcohol shipments could be made Monday through Saturday from seven o'clock in the morning to five o'clock in the evening, while Sunday deliveries were forbidden. The delivery package had to follow a tight chain of custody procedure whether shipped by rail, automobile or any other

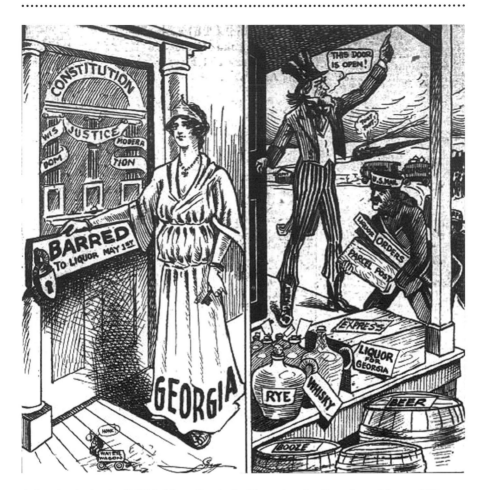

A drawing in the April 1916 *Atlanta Constitution* illustrating dry Georgia and the wet U.S. Mail. Note the jug train in the background. *Courtesy of www.Fold3.com.*

means. The alcoholic drinks had to be shipped from outside the state and consumed within thirty days or destroyed; no storage was allowed above the specified volumes.

## THE FINAL DAYS OF THE SALOON AND NEAR BEER

Approximately 180 near beer saloons and seventeen locker clubs closed on May 1, 1916. From late 1915 to the final days of April 1916, near beer

license cases were still challenged in court, and the number of blind tiger cases began to rise. The new legislation allowed no wiggle room for near beer or locker clubs. In the final days before state prohibition, near beer saloons were emptied, and many had rental signs hanging in their windows. The many tied houses of the Atlanta Brewing and Ice Company were being shut down and the fixtures removed.

Effectively, the saloon disappeared as an Atlanta drinking establishment. Its presence was abolished so completely that the term was not used again until decades later and then only sporadically. Photographs of Atlanta saloons are extremely rare, leading us to wonder if the Drys found several ways to erase the saloon from local history.

The Atlanta Brewing and Ice Company amended its charter to reflect a new company name: the Atlanta Ice and Bottling Company. It survived by producing "soft" drinks with less than 0.5 percent alcohol, bottling for other soft drink companies and producing ice. The new name was put in place to avoid a lawsuit from the Georgia ASL, which might pursue the word "brewing" as a violation of the anti-advertising elements of the new law.

The new legislation outlawed advertisements for alcohol, regardless of format. The strict regulations on alcohol ads and shipments into Georgia virtually destroyed the mail-order whiskey business. Chattanooga-based whiskey dealers posted notices suggesting that Atlanta customers cut out the dealers' final ads and keep them as a way to order in the future. The jug train was quickly reaching the end of the line.

## NEAR BEER BY ANY OTHER NAME

Two of the longest-running temperance near beer beverages in Atlanta were Great American Hop Ale and White Hops. Great American Hop Ale was a beverage produced by the Atlanta-based American Beverage Company. This drink was truly a nonalcoholic beverage, containing only trace amounts of alcohol. Basically, it was a "hop tea" with caramel coloring and saccharine, marketed from 1902 to 1912. If this beverage followed the track of others of its time, Hop Ale may have been used as a base to which alcohol could be added to camouflage an illegal drink.

White Hops, occasionally in German *Hopfen Weiss*, first appeared in 1894 in South Carolina. Evidence suggests that White Hops was a lager beer of

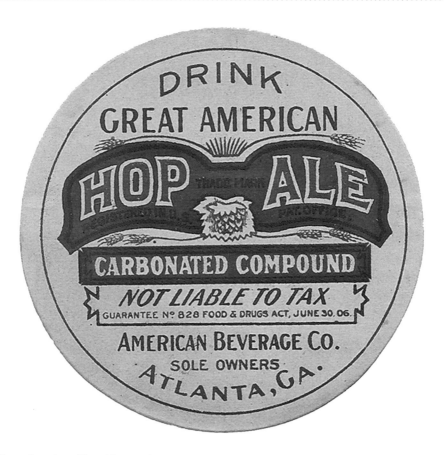

Great American Hop Ale, a carbonated and sweetened hop tea–like prohibition beverage made by the American Beverage Company of Atlanta. *Collection of Ron Smith.*

about 3 percent alcohol by volume. This would have made it a legal near beer beverage in Atlanta until May 1916, as long as a near beer retail license was procured. However, it was often sold in fruit stands and sandwich shops on the sly to avoid the tax. This beverage played a part in the Atlanta near beer wars, where the legality of taxation of near beer beyond that of soft drinks was originally disputed.

It appears that the Atlanta Brewing and Ice Company was involved and distributed White Hops through a clearinghouse possibly known as the White Hops Agency. All receipts and invoices between the two businesses were listed simply as "hops," a common and unlicensed brewery commodity. The drink and its producers survived many court cases. The last mention of White Hops in Atlanta newspapers appeared

History repeats itself: White Hops at Three Taverns Craft Beers. The beer is of a different style, but a historic name has returned. *Ron Smith.*

in December 1913. Although for a different type of beer, the name "White Hops" was resurrected in 2013 by Three Taverns Craft Brewery in Decatur, Georgia, giving a nod to the historic and controversial prohibition beverage.

## ALCOHOL AND ANTI-IMMIGRANT SENTIMENT

Atlanta's immigrant minorities, especially those of Catholic, Jewish or Lutheran faith, did not view alcohol as socially taboo. These ethnic minorities were often employed by the service and beverage alcohol industry. Their European and now "Euro American" social culture accepted alcohol in moderation and even mandated it for some religious ceremonies.

Dr. Marni Davis's book *Jews and Booze* points out that three of Atlanta's prominent alcohol businessmen were Jewish: Albert Steiner, president of Atlanta's brewery; Aaron Bluthenthal, co-owner of Bluthenthal and Bickart, a whiskey wholesaler; and Joseph Jacobs, who owned a pharmacy

chain that sold medicinal and beverage alcohol. Jacobs's pharmacy played a key role in John Pemberton's development of a temperance version of his French Wine Coca.

Around the turn of the twentieth century, Decatur Street was Atlanta's only major integrated section. African Americans, Chinese, Greeks, Italians, Russians and Syrians lived and plied their respective trades on or near this street. One of the most common Decatur Street occupations was that of saloonist (saloon operator). It is thought that Russian Jews constituted half of Decatur Street's saloonists by 1905. Besides being liberal toward alcohol consumption, these immigrant groups held a socially progressive view of race relations. Many saloon owners ran integrated saloons until the Atlanta Race Riot. As Jim Crow laws strengthened after the riot, many Jewish operators ran colored-only saloons.

These relaxed attitudes toward alcohol and race relations did not sit well with Evangelical Protestants, who made up the vast majority of the Drys. A quote from *Race, Social Reform, and the Making of a Middle Class* sums up this social perception: "Blacks and racially ambiguous European immigrants were frequently associated with threats to family, either in the form of rapidly multiplying populations that threatened to overrun the Anglo-Protestant native born or as procurers and peddlers of vice that lured the young into lives of moral dissipation."

Nativism (anti-immigrant sentiment) has a long history in the United States and tends to peak during periods of significant social change. In the late 1800s and first decades of the 1900s, Reconstruction, industrialization, urbanization and social reform (in this context, prohibition) were catalysts for Nativist sentiment. Nativists believe that all immigrants need to abandon any pre-migration religious and political ideologies, as well as cultural practices that do not fit the Nativist view of American values. For the Drys, the Old World attitude toward alcohol was foremost among the immigrants' undesirable practices. Atlanta's Drys pointed to the immigrant-operated saloons on Decatur Street as an acute manifestation of this foreign corruption. They especially resented immigrant-operated saloons that catered to African American clientele.

Despite the Drys' revulsion toward Decatur Street, visitors from everywhere toured the street by car or on foot. Detractors of this area called the trips "slumming." To use a modern term, Decatur Street was edgy. Near this famous (or infamous) street was Atlanta's red-light district. Vice and criminal activity did exist on Decatur Street, but the living hellhole described by Evangelical Protestants is not supported by historical data. Some visitors were indeed

looking for the seedy part of humanity, but many others were drawn to observe or take part in a multiracial and international business district.

Within this area were beginnings of what some people of the time called the New South. The Drys failed to take into account any social factors other than alcohol and wickedness that led people there. The saloons and dance halls, however, provided immigrants and African Americans with something that the rest of Atlanta seemed to deny them: a sense of community.

## Women and Drinking

Another European custom that Drys found unsettling was women drinking in public. Even more disturbing was the concept of men and women drinking together. By dry standards, women should not drink at all, especially in public. A woman drinking in public was one more step in the wrong direction; the Drys were already trying to keep men from drinking openly. A quote in the *Atlanta Constitution* highlights this 1907 dry viewpoint: "In many of the near-beer saloons both men and women congregate, sitting around tables, drinking the near stuff with all the riotous enjoyment and hilarious feeling."

As noted in *Domesticating Drink*, women in more restrictive societal circles chose to drink in private if they were inclined. Many nondrinkers took

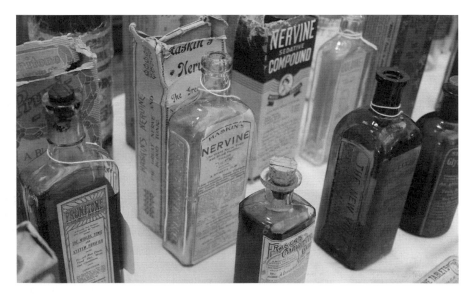

Generally having high alcohol content, many patent medicines also contained opium and/or cocaine. Bottles from the collection of Ken Evans. *Ron Smith.*

regular doses of patent medications to deal with "nerves" or other perceived female illnesses. Many temperate women were shocked when the Pure Food and Drug Act of 1906 revealed that many of their regular patent medications contained as much as 22 percent or more alcohol by volume, along with substances such as morphine, opium and cocaine. A 1904 survey reported that 75 percent of the WCTU members polled regularly took patent medicines.

## The Case of Sig Samuels

If any Atlanta story captures the effects of anti-saloon legislation, anti-immigrant sentiment and the invasion of privacy of one's home via prohibition, it is the account of Jewish immigrant and businessman Sig Samuels.

Samuels was one of Atlanta's successful businessmen highlighted in the 1922 circular *Men of the South*. Though most noted for ownership of some of Atlanta's premier theaters from 1912 to the 1920s, he was also associated with other businesses. Born in Germany and educated in America, he worked as a clerk in a dry goods store from 1893 to 1897. Then, until 1912, he owned a mail-order mercantile business and other business ventures. This mail-order business likely included some legal jug train business.

One of Sig's many businesses was located at 33 West Mitchell Street. This handsome building, which he purchased and redesigned, was home to Sig Samuels' Buffet. Besides offering a sizeable sidebar of cold cuts, meats and other lunch items, it had one of the city's most impressive liquor selections. In addition to national brews, the buffet offered the locally brewed Steinerbräu. After the 1907 state prohibition went into effect, it operated as a near beer saloon and was one of many businesses involved in the controversy over near beer licenses, lunch licenses and illegal "free lunches." Amazingly, the structure is still intact (now 199 Mitchell Street Southwest).

Sig was plaintiff in a court case against the sheriff of DeKalb County (*Samuels v. McCurdy*) involving "large quantities of whiskies, wines, beer, cordials, and liquors" that were seized at Samuels's private residence. Samuels argued that the liquor had been purchased prior to the 1915 amendments of the 1907 state law. In the case, which was appealed to the U.S. Supreme Court, legal representatives argued that under the law at the time, the "ultimate legislative object of prohibition is to prevent the drinking of intoxicating liquor by any one because of the demoralizing effect of drunkenness upon society." They further argued that "the

The former location of Sig Samuels' Buffet, one of the few remaining Atlanta structures that once operated as a saloon. *Ron Smith.*

necessity for its destruction is claimed under the same police power to be for the public betterment." The presiding judge was Chief Justice William Taft, who from 1909 to 1913 had been the twenty-seventh president of the United States.

# DRASTIC TO RADICAL—THE BONE-DRY LAW OF 1917

In Georgia and across the nation, the prohibition movement matured into a successful political machine. Drys collectively lobbied to pass three national acts dealing with federal commerce. First, the cash-on-delivery (COD) law of 1909 tightened control on deliveries of alcohol. Second, the Webb-Kenyon Act of 1913 allowed dry states to regulate interstate liquor shipments into their territories. Third, the Reed "Bone-Dry" Amendment to the U.S. Post Office Appropriations Act made it illegal to use the U.S. Post Office for interstate transportation of alcohol into dry states unless for medicinal, sacramental or mechanical purposes.

The passage of national laws strengthened existing state prohibition legislation. The national leadership of the ASL issued a statement to the press saying that that the Reed Amendment had "cleared the decks" for a national Prohibition amendment.

The ASL and the WCTU had launched a nationwide campaign for passage of the Webb-Kenyon Act. They argued that blind tigers were using supposedly private alcohol shipments to supply their trade within dry states. Once passed, court cases backing these laws added fuel to the bone-dry movement. *Shaping the 18th Amendment* defines bone-dry as "the banning of all liquor shipments into a state or the personal ownership of liquor." The terms "bone-dry" and "radical prohibition" became newspaper buzzwords.

The year 1917 blew in a prohibition whirlwind. A total of eighteen states adopted some version of bone-dry law, and the U.S. Supreme Court supported the constitutionality of these laws. Georgia was among these states. Governor Harris, in his inaugural address, had expressed his hard stance on prohibition, and the Georgia ASL made sure he kept his word.

After a railroading legislative session, Governor Harris signed the bone-dry law into immediate effect on March 28, 1917. He applied his signature the same day the legislature voted on the bill. The following day, the *Atlanta Constitution* headline declared: "GEORGIA NOW 'DRYEST' STATE IN COUNTRY."

An early 1900s temperance rally on Whitehall Street in Atlanta. The banner reads, "Booze—Under the feet of the American Youth." *Collection of Ron Smith.*

Elliott Street Pub in Castleberry Hill. Federal agents raided this building in September 1916, seizing one hundred gallons of whiskey and two unlicensed copper stills (contraband under the bone-dry law). *Ron Smith.*

The article went on to state that "every citizen of Georgia who…has a drop of liquor, beer or any other intoxicant in his possession is a violator of the law."

The law, as described in the local paper, stipulated that to have, control or possess any of several listed liquors or beverages, whether for personal use or otherwise and whether at home or anywhere in the state, was illegal. Theoretically, a person who had purchased liquor by legal shipment the day before was now breaking the law by possessing the very same liquor. The only legal alcohol was pure alcohol for medical or industrial use and sacramental wine. Druggists, priests and rabbis had to submit signed applications to obtain state permits (licenses) to possess alcohol at their respective locations. Any druggist or doctor caught in violation of this law would be banished from practicing in Georgia.

Another portion of the bone-dry law specified that "all apparatus or appliances which are used for the purpose of distilling or manufacturing any of the liquors or beverages specified in this act are hereby declared to be contraband." It is theorized that the Atlanta Ice and Bottling Company (the former brewery) got around this potential contraband seizure by using the same equipment to make nonalcoholic cereal beverages and other soft drinks. Commercial distillers, such as the R.M. Rose Company, had already moved their distilling equipment and whiskey stock to neighboring states in the first round of state prohibition.

## THE DERAILED JUG TRAIN

Personal orders, alcohol advertisements and transportation of beverage alcohol in Georgia were all illegal. In Atlanta, if a person wanted a drink, the only way to get it was by nefarious means such as blind tigers. The jug train had proven popular, but after Governor Harris's signature, this activity became a liability to the railroad freight companies. A

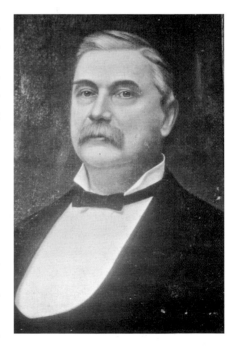

Rufus Mathewson Rose, owner of the R.M. Rose Company. *Georgia Archives, Vanishing Georgia Collection, image number ful405.*

hidden shipment of illegal whiskey could risk court action against transport company personnel or worse.

A multitude of local whiskey distillers, blenders (rectifiers) and wholesalers had survived the 1907 Prohibition Act by moving outside the state and operating through mail order. A few survived the tightening noose of state prohibition laws in 1915. In the final years, these businesses survived on the limited quantity personal use trade (two quarts per month per person). The wave of state bone-dry laws swept away the survivors, thus ending the legacy of the jug train. Of such relocated businesses, the R.M. Rose Company is the most noteworthy.

# THE R.M. ROSE STORY

Rufus Mathewson Rose built a distillery in 1867 on Nancy Creek at Stillhouse Road, located in modern-day Vinings. There, he operated a traditional copper still to make corn whiskey. Started as the "House of Rose" (and later called "Rose, the Distiller"), the company finally settled on the name R.M. Rose Company.

According to advertisements in local newspapers, the business had more traditional corn whiskey in its U.S. government–regulated (bonded) warehouse than all other whiskey dealers and distillers in the country combined. This whiskey was loaded onto railcars and shipped to the nearby city of Atlanta, where *Atlanta City Directories* indicate the company owned a warehouse on Auburn Avenue, as well as wholesale outlets on Peachtree and Broad Streets.

Rose was a shrewd whiskey retailer; he made sure all of his retail whiskey jugs and bottles touted the company logo. He also promoted tours to inspect the distillery, warehouses and outlet stores. Research indicates that he attempted to operate in a professional and legal manner despite ever-tightening alcohol regulations.

In 1905, Randolph Rose assumed leadership of the family business. However, operating would be tough for Randolph, and the company's survival was challenged by state prohibition amendments. During the 1885–87 Fulton County local option dry period, Randolph's father had continued business by jug train. He would do the same during the first two decades of the "dry" 1900s.

During the Georgia state prohibition years, the R.M. Rose Company arguably did more advertising than any other distillery in the country. This

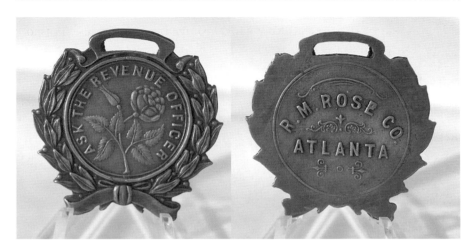

*Above*: An R.M. Rose Co. pocket watch fob. "Ask the Revenue Officer" is a reference to the government having confirmed that its whiskey was "medicinally pure." *Courtesy of Butch Alley.*

*Right*: The Rufus Rose family vault located in Atlanta's Historic Oakland Cemetery. *Ron Smith.*

continued until the 1916 amendments to the Georgia prohibition act forbade liquor advertisements in any medium. The R.M. Rose Company persevered under the continual onslaught of prohibition laws. By 1917, Randolph Rose had been effectively legislated out of business, leading him to close shop and file bankruptcy. Both Rufus Mathewson Rose and Randolph Rose lie in eternal repose in their family mausoleum at Atlanta's Historic Oakland Cemetery.

The ghost of the jug train would be invoked by Mary Russell, president of the Georgia WCTU, in a letter presented to the Georgia Senate Committee in 1935 and now preserved in the Emory University archives:

> *Now I happened to have lived in the older days, and many times on my way to high school, have stopped at the R.R. tracks by the old union station, while a long freight train rolled in from Chattanooga, with box cars piled high with barrels, marked X.X.X. Rose whiskey.*

## THE PERSISTENCE OF ILLEGAL DRINKING

A May 1916 *Atlanta Constitution* article claimed that 2,500 gallons of liquor were taken from blind tiger raids over a period of six days. A "whiskey squadron" of five detectives made the arrests and seizures starting on May 1, the first day of the new state restrictions.

During this spree, restaurant owner Jim Daulis was arrested at his business located at 199 Peters Street. The detectives found 2,200 pints and 281 half pints of whiskey and one barrel of beer at his restaurant. The officers located a removable section of flooring near the front of the business and found the liquor in the subfloor space.

This would be the first in a series of arrests involving Daulis, who apparently ran a large-scale operation. Two days later, a system of tunnels was found at his rental property on Harwell Street a mile beyond the end of the West Hunter streetcar line (roughly modern-day Ashby MARTA Station). The entrance to the tunnels was a trapdoor on the back porch. Beneath, a second trapdoor was concealed under a layer of soil. This second trapdoor led to a well twenty-five feet deep that was half filled with dirt. Upon inspection, a vertical shaft contained not soil but fifty-two sacks of whiskey, each containing fifty half-pint and quarter-pint bottles.

On the same property, a horizontal tunnel was found leading to a subterranean chamber below the residence's dining room. There, the

The approximate location of Jim Daulis's restaurant and illegal whiskey storehouse, modern-day Peters Street. *Ron Smith.*

detectives found the remnants of a still. The smoke from the distillation process ran into a pipe that went directly into the chimney of the dining room. In the attic of the house, the detectives found over two hundred bottles of beer and several pints of whiskey. This was Daulis's second arrest but not his last.

Daulis also received charges of keeping 1,502 half pints of whiskey stored in sacks in a vacant storeroom at 207½ Peters Street. He and his associates would produce the whiskey at the Harwell Street "whiskey farm," transport it to the 207½ Peters Street property (now 283 Peters Street) and store it until it could be sold at his Greek restaurant just down the street. Sergeant Waggoner stated during the second raid, "It is a lesson to us, showing to what extremes these people will go in hiding and concealing liquor."

Georgia prohibitionists could obviously strengthen the law all they wanted. What they could not seemingly do is get citizens to stop producing or drinking beverage alcohol. According to the *Georgia State Capitol—Historic American Buildings Survey*, six days after the bone-dry law went into effect a female clerk watched a young couple casually pass a quart jar between themselves on the third floor of the Georgia State Capitol Building. According to the eyewitness account, the smell of moonshine lingered in the hallway for a long time.

## FROM STATE TO FEDERAL

The wave of bone-dry laws added state after state to the list of dry territories. Prohibitionists were using the same small victories approach that had won them local option and the first state prohibition legislation. Under de facto leadership of the Anti-Saloon League of America, they planned for the next step: a nationwide prohibition law. A local Dry was quoted in April 1916 as stating, "The enemies of nation-wide prohibition are finding grim comfort in the rapid-fire victories for state wide prohibition so widely scattered over the nation."

All the prohibition movement needed was forward momentum to achieve national legislation. In 1917, the Drys were given the perfect catalyst for launching a stronger push toward nationwide prohibition: World War I.

## Chapter 7

# INCOME TAX, THE KAISER AND NATIONAL PROHIBITION

*Children of future generations, reading the history of these days, will feel their hearts grow with pride in the knowledge that their ancestors were soldiers in the great war for moral freedom.*
—*Georgia's ASL and WCTU on ratification of the Eighteenth Amendment,*
Atlanta Constitution, *1918*

## INCOME TAX AND PROHIBITION

In the early days of the United States, the government's operating expenses were mainly covered by taxes on distilled spirits, imports (tariffs) and other excise taxes. Personal income tax had been used to help pay for the Civil War but then discontinued in 1872. One of the biggest problems faced by the Anti-Saloon League (ASL) was the government's dependence on alcohol taxes, which in 1900 provided over 60 percent of internal revenue collections.

As early as 1883, the WCTU had argued that a personal income tax would wean the government off liquor taxes. During the debate for the Sixteenth Amendment, temperance politicians and lobbyists developed a rapport with the backers of the income tax. With the passage of the amendment leading to reinstitution of income tax, the Drys argued that the government no longer had tax revenues as an excuse for defending the liquor interests. One huge hurdle had been removed, allowing the dry movement to push for nationwide Prohibition.

# WORLD WAR I

Prior to America's entry into the war, many Protestant denominations were against U.S. involvement. German Americans were trying to stay neutral as hostilities in Europe increased. They feared backlash against their communities if America entered the war. Aggression against native-born and immigrant Germans in Canada and Australia had already occurred.

In April 1917, the United States entered the Great War in Europe. The country had been able to ignore the militant swagger of Kaiser Wilhelm II, the growing military power of Germany and the outbreak of war. Yet the German war crimes in Belgium and unrestricted submarine warfare responsible for the death of American citizens slowly turned opinion against Germany.

Entry into the war was not popular with many American citizens, and President Wilson had to rely on an immense propaganda campaign to bolster public support. The Drys were already well versed in propaganda and used the emerging war effort to support their interests.

## Anti-German Sentiment

Unfortunately for German American brewers, they had banked their anti-prohibition campaign on the wholesomeness of German culture, a hard work ethic and a reliance on beer—virtually liquid bread—as central to it all. The war and resulting anti-German propaganda tainted that imagery. *Over-the-Rhine* synopsizes this point, stating, "The war brought a new type of nationalism and a wave of nativist hatred that was both familiar and unprecedented, and it shifted very quickly against the Germans." Prewar, most of the anti-immigrant sentiment was directed toward immigrants from other European nations. World War I's propaganda framed anything German as decidedly anti-American.

Although we found no violent outbreaks against Atlanta's German American population in our research, German social societies like the Turn Verein quickly faded into history. The local German beverage industry workforce, with its noted saloon owners and brewers, also drifted into obscurity.

On a national level, the ASL made a direct attack on any remaining German American brewers in wet states, calling them the worst of America's enemies. They denounced lager beer as "Kaiser brew." An ASL pamphlet labeled the brewers as "un-American, pro-German, crime-producing, food-

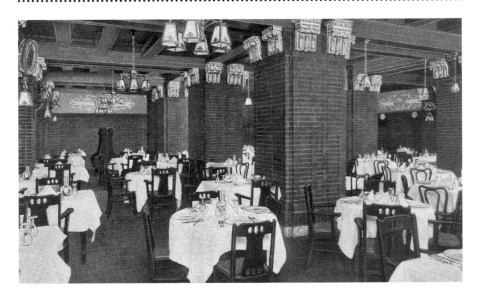

Hotel Ansley's rathskeller. The term was popular for cellar restaurants/bars until World War I. I.F. Company, Inc., Atlanta, early 1900s. *Collection of Ron Smith.*

wasting, youth-corrupting, home-wrecking, treasonable liquor traffic." One prohibition postcard went so far as to portray German American brewers hanged outside a brewery. It was a rout of the last organized wet defense.

The prohibition movement successfully wrapped itself in wartime patriotism. If a person denied prohibition, he or she was supportive of German interests and could possibly be branded a traitor. While troops trained in nearby Camp Gordon (where modern-day Peachtree-DeKalb Airport is located), the army of Drys made their final surge for national Prohibition.

## The Wartime Fast Track to National Prohibition

An article in the Fourth of July 1917 edition of the *Atlanta Constitution* is titled "War Time Prohibition Demanded of Congress." The subtitle details further: "22 Temperance Organizations Ask Barring of Foodstuffs for Making Alcoholic Drinks." This new law, the Lever Food and Fuel Control Act, passed in August 1917 as a wartime act giving the U.S. president tight control over the nation's food and fuel supply. This act forbade the production of distilled spirits from any produce that was used for food. Following the Lever Act was the Wartime Prohibition Act on November

18, 1918 (effective on June 30, 1919), which prohibited the sale of beverage alcohol over 2.75 percent ABV. This law took effect during the ratification process of the most memorable prohibition law in the country's history: the Eighteenth Amendment.

# THE EIGHTEENTH AMENDMENT AND THE VOLSTEAD ACT

## A Prohibition Amendment to the Constitution

Congress introduced a Prohibition Amendment in 1917. This proposed amendment to the U.S. Constitution was constructed by the Anti-Saloon League of America and its political allies. As the document passed between the Senate and the House of Representatives, the Wets made their last plea, arguing that remaining beverage alcohol interests needed time to settle their affairs before the amendment went into place. The ASL lobbyists grudgingly allowed this concession, allowing the amendment to go into effect one year after it was passed. One other important change before its passage gave concurrent enforcement powers to the states and the federal government.

The final resolution passed the U.S. House on December 17. The following day, the Senate concurred with the changes, and Congress offered the proposed Eighteenth Amendment to the states for ratification. The general feeling among members of Congress was that if the individual votes had been kept secret, the amendment would have never passed. Congress, like the local and state politicians before them, feared retaliation by the ASL. Voting against the wishes of the ASL had historically equaled political suicide.

The ASL state chapters were ready and well organized for the ratification process. *Pressure Politics* notes that "the grip held by the Anti-Saloon League over the state legislatures was never better illustrated than in the manner in which these bodies obeyed the command to ratify." The ASL had nothing to worry about with the State of Georgia. The state senate passed the amendment in four minutes and fifteen seconds, and the house followed suit, albeit at a slower pace. On June 26, 1918, Georgia became the thirteenth state to ratify the prohibition amendment.

Seven months later, ratification was complete when the thirty-sixth state (Nebraska) ratified the amendment, which was promptly certified by the U.S. secretary of state. The Eighteenth Amendment was scheduled to go into

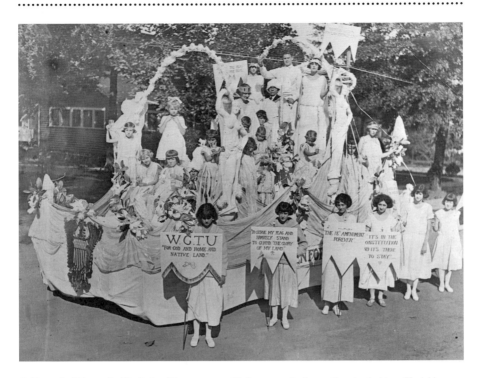

A Georgia Woman's Christian Temperance Union parade float. *Georgia Archives, Vanishing Georgia Collection, image number dec014.*

effect on January 17, 1920. The amendment itself was startlingly exact and brief. To better define the language, Congress passed enabling legislation via the National Prohibition Act (aka the Volstead Act) on October 28, 1919, which gave teeth to the Eighteenth Amendment.

## The Volstead Act

The manufacture of any beverage alcohol outside the strict provisions of the National Prohibition Act was forbidden. Liquor for medicinal purposes was allowed if a person had a prescription from a certified physician. Wine for sacramental purposes was allowed if the proper federal permit was obtained. Such medicinal liquor and sacramental wine was manufactured under tightly regulated government oversight, and liquor for medicinal use was kept in government-inspected and controlled warehouses.

Buying, trading or gifting alcohol was forbidden. Importing to and transporting alcohol within the United States was disallowed, as was

*Above*: A U.S. Treasury Department National Prohibition Act medicinal alcohol prescription blank, filled as with a contemporary prescription. Illnesses requiring medicinal alcohol oddly increased during Prohibition. *Collection of Ron Smith.*

*Left*: Wayne B. Wheeler, de facto leader of the national ASL. The Eighteenth Amendment likely never would have occurred without his lobbying efforts. *Library of Congress.*

shipping liquor through the mail. Possessing liquor in any public area, including seemingly private spaces such as hotel rooms, was illegal. Liquor advertisements were not allowed under the Volstead Act. Buying and selling of formulas or recipes for homemade liquors were also forbidden.

Under the National Prohibition Act, personal ownership of beverage alcohol was allowed with no quantity limits. A person could drink in the privacy of his home and in the homes of his friends. If a person moved, he could apply for a permit to move his liquor. However, during development of the amendment, the ASL wanted personal ownership of beverage alcohol to be illegal. Three representatives voted to outlaw personal ownership of beverage alcohol. One of those votes was William Upshaw of Georgia.

## The Winds of Change

The Volstead Act through the Eighteenth Amendment was designed to deplete the supply of beverage alcohol for casual use in America. Even the wealthy, with their large stashes, were sure to run out after a period of time. The Drys figured it was only a matter of time until the vast majority of Americans was teetotal abstinent and the lawbreakers were in jail where they would be dry until rehabilitated. Addressing a crowd the day before nationwide Prohibition went into effect, the renowned evangelist Billy Sunday said, "Men will walk upright now, women will smile, and the children will laugh. Hell will be forever for rent." In the 1920s, two primary factors would change American life forever: technology and Prohibition. The Drys had their social change, but it would not be the change they were looking for.

# ATLANTA AND NATIONAL PROHIBITION

You would think that national Prohibition was a bit anticlimactic for many citizens of Atlanta, as they were already under more restrictive prohibition legislation. For Drys in Atlanta and across American cities, though, the changing of the U.S. Constitution was a huge victory. This law was surely permanent, as no amendment to the Constitution had ever been repealed.

The day prior to countrywide Prohibition, a person dressed as Uncle Sam rode a symbolic water wagon around Atlanta giving tours and letting everyone know of the big celebration planned that night. A biplane containing the coffin of John Barleycorn (the personification of alcohol) flew

Five Points—the intersection of Edgewood Avenue, Whitehall (now Peachtree), Decatur and Marietta Streets—in the early 1900s. Imperial Post Card Company, Atlanta. *Collection of Ron Smith.*

low over the city and dropped Georgia ASL flyers announcing the festivities. As night descended, temperance societies and their leaders gathered in a self-congratulatory meeting and then joined a parade headed downtown. One of these temperance-minded groups, reorganized in Atlanta just five years earlier, was the Ku Klux Klan.

In the center of Five Points at midnight on January 16, 1920, a towering effigy of John Barleycorn was placed on top of a funeral pyre containing an illegal moonshine still. Leaders and citizens poured contraband whiskey onto the pyre as the crowd cheered. At 12:01 a.m. on January 17, as mandated by the Eighteenth Amendment of the Constitution of the United States, the country was declared dry.

# LAW AS CLEAR AS GEORGIA RED CLAY

The Volstead Act is subject to interpretation based on context. Adding to that confusion was the concurrent power of the states and the federal government for enforcement of the law. This theoretically meant that individual states could enforce an equivalent or stricter alcohol prohibition but could not relax the terms of the law within their borders. As of 1917, Georgia already had a stricter bone-dry law in place. Therefore, State of Georgia prohibition officers could arrest under the state's more tightly regulated statute. Federal officers, on the other hand, ignored the state laws and sought to enforce only the National Prohibition Act.

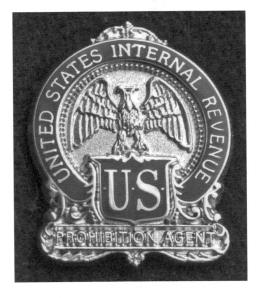

A reproduction lapel pin depicting the badge worn by U.S. Internal Revenue Prohibition agents from 1920 to 1926. *Ron Smith.*

Court cases across the nation varied on interpretation of concurrent state and federal laws and how they were to be enforced. In a Florida case, it was determined that the national Prohibition law was dominant over state law. In many other states,

This form is taken from MILLS' UNITED STATES COMMISSIONERS MANUAL.

[UNITED STATES COMMISSIONER'S BLANKS. NO. B.]

WARRANT TO APPREHEND.                    The W. H. Anderson Co., Law Publishers, Cincinnati, Ohio.

# The President of the United States of America,

TO THE MARSHAL OF THE UNITED STATES FOR THE....Southern......

DISTRICT OF.....Georgia...........

AND TO HIS DEPUTIES, OR ANY OR EITHER OF THEM:

WHEREAS,        E.L. Bergstrom.....................,has made complaint in writing under oath before me, the undersigned, a United States Commissioner for the........Southern.........District of .....Georgia,.Western.............

Division charging that......John I. Aaron.............

late of........Toombs...................County, in the State of....Georgia.......
            20th of November 1924, and
did, on or about the....3rd.............day of....Jany,.......................

A. D. 19. 25, at...Toombs.County.......in said District, in violation of Section

3.....................................................................of the

Nat'l Pro Act        unlawfully ...manufacture liquor.......

A 1925 United States warrant for violation of the National Prohibition Act. *Collection of Ron Smith.*

the determination seemed to be that concurrent power meant equal and independent power.

As an example, in the 1921 Georgia Supreme Court case *Cooley v. the State*, it was determined that "the eighteenth amendment to the constitution of the United States, and the National Prohibition Act, known as the Volstead act, do not supersede or abrogate the Georgia prohibition statute of March 28, 1917." The case decision allowed that a person being charged with a Volstead Act violation (federal) could also be tried for a Georgia bone-dry law violation (state).

This general confusion was underscored by a scarcity of funding and agents at all levels of law enforcement. The combination of factors made it difficult to enforce the prohibition laws and to successfully prosecute the resulting cases. Regardless of these barriers to prosecution, there was no shortage of arrests for violation of the law during all of Atlanta's prohibition periods. As the law became more restrictive, lawbreakers became more innovative in keeping the city wet.

Chapter 8

# TIGER KINGS, WHITE LIGHTNING AND THE DIXIE HIGHWAY

*No longer a disreputable crook, the criminal had become the efficient provider of highly desired merchandise.*
—*David E. Ruth,* Inventing the Public Enemy:
The Gangster in American Culture, *1996*

## THE TIGER KINGS

Although blind tigers stretched back to the 1800s, highly organized illegal alcohol retail in Atlanta was not mentioned in the popular press until a few years after state prohibition. Around 1910, two gentlemen emerged as heads of competing blind tiger networks. These networks were known to buy liquor from various out-of-state dealers and then ship it to Atlanta under fictitious names of individuals or clubs. The alcohol was stored in secret warehouses until it could be repackaged in smaller quantities and sold to large groups of street-dealing "pocket tigers." These two bosses would be known by the local press as "tiger kings."

Dan Shaw, a twenty-seven-year-old former prizefighter, was arrested in Atlanta in 1909 for selling whiskey as a pocket tiger. Three and a half years and many arrests later, he was infamously known as King Shaw in the Atlanta whiskey underground. By all newspaper accounts, Shaw was a likable and

courteous gentleman who looked more like an artist or actor than the leader of an organized whiskey-selling ring. In addition to his good looks, he had "smiling eyes" and was always whistling and grinning. In a former life, Dan had worked as a mechanic and civil engineer in Panama.

By the time of his first arrest, Shaw had been in the city for more than five years and was selling illegal whiskey in small quantities. Over the next few years, he built a blind tiger network to sell his illegal hooch. When a large social event was held in the city, Shaw could rake in as much as $1,700. From 1909 to 1913, he oversaw the sale of $500,000 worth of booze. During this time, he was arrested nearly fifty times and paid more than $15,000 in fines—a small penalty compared to the profits of the operation. Besides the Atlanta Police, Shaw had a rival in the tiger king known as "Hub" Talley.

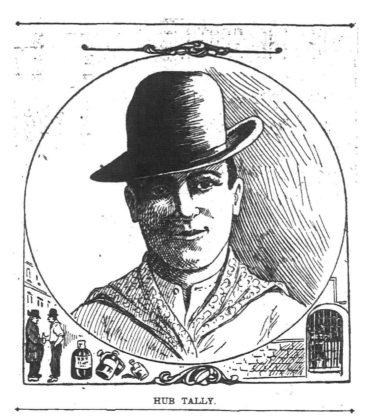

HUB TALLY.

A drawing of the notorious Atlanta tiger king Hub Talley (incorrectly spelled in this sketch). *Atlanta Constitution*, November 1911. *Courtesy of www.Fold3.com.*

By October 1911, Herbert W. Talley had been arrested seventeen times on charges ranging from violation of the blind tiger ordinance to keeping whiskey on hand for the purpose of sale and assault with attempt to murder. While imprisoned in police headquarters in 1911, he was described by the *Atlanta Constitution* as a small, slim-built fellow; twenty-four years of age; with piercing black eyes. He was sharply dressed in a pressed silk shirt with a silk handkerchief tied around his neck, topped by a jaunty hat.

Whereas Dan Shaw is reported to have been unassuming and perhaps gentlemanly, Hub Talley appears to have been violent and potentially mentally unstable. Hub was fond of gunplay; he would often get drunk and walk into places and start shooting. On more than one occasion, he cleared an Atlanta saloon faster than a temperance sit-in. Court witnesses testified that Talley used to be a mild-mannered soda jerk. Perhaps in explanation, they recounted that Hub suffered a head injury in a railroad accident and afterward his behavior changed for the worse.

Talley's record as a blind tiger stretches back to the early 1900s. He moved up through the ranks in a fashion similar to Dan Shaw. However, Talley held together his tiger kingdom by fear and intimidation. It was well known that Hub was not afraid to cut or shoot someone. Early in his criminal career, he apparently killed a man called Lipes in a Piedmont Street hotel. Hub himself was at one point shot in a hotel in the same area and was associated with several "accidental" shootings. Tally and a cohort, George "Crip" Blackstock, took part in the 1906 Atlanta Race Riot. Both men were seen shooting pistols at fleeing blacks on Peters Street during the chaos. They were indicted on assault to commit murder, but it is unclear if they were ever charged.

In 1911, the Shaw and Talley blind tiger factions began what Atlanta police called the city's "whiskey war." There was surprisingly little documented gunplay between the two rival blind tiger factions given that Hub Talley was involved; most of the turf war was fought by each faction turning in evidence against the other. Dan Shaw and his closest associates, William "Whiskey Bill" Clay and O.E. Pickett, were arrested multiple times on evidence supplied by the Talley gang. In return, Talley's brother-in-law and another associate ended up in jail several times on evidence provided by Shaw's men. In October 1911, Hub Talley personally threatened Whiskey Bill and Pickett, who were witnesses against Talley in court. He threatened that he would shoot them as soon as he was released. He never fulfilled his threat, as Hub disappeared from the courthouse before they could arrest him on contempt of court.

A blind tiger political illustration in the May 1916 *Atlanta Constitution*. *Courtesy of www.Fold3.com.*

Before Atlanta's whiskey war was concluded, Hub Talley was arrested more than forty times and twice judged insane in attempts to avoid the chain gang and extended jail sentences. In 1914, he was found guilty of shooting his former race riot partner, Crip Blackstock, in an attempt to murder him during an argument over stolen whiskey. This is the last mention of Talley in historical documents.

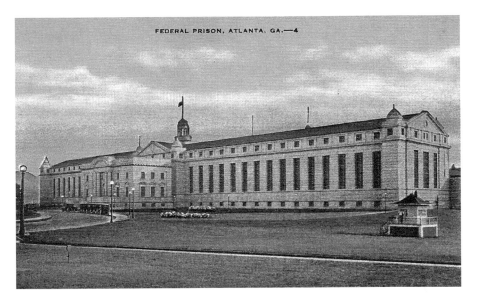

FEDERAL PRISON, ATLANTA, GA.—4

The Atlanta Federal Prison, temporary home of Prohibition gangsters Al Capone and George Remus. R&R News Co., early 1900s. *Collection of Ron Smith.*

Tiger king Dan Shaw left Atlanta after his 1913 sixty-day prison sentence. He returned to Virginia, likely Richmond, where he took up another trade and rejoined his family. He was married and had two children during his years as King Shaw in Atlanta. His family lived away from the whiskey war, either in North Carolina or Virginia, and knew very little of his Atlanta activities. However, the *Atlanta Constitution* notes that Dan Shaw's wife wrote a letter to the governor of Georgia in 1913, asking him to overturn Dan's remaining sentence.

Atlanta's troubles with blind tigers and organized crime did not end with the absence of Shaw and Talley. Illegal and/or untaxed liquor had flowed into the city since its days as Marthasville and would continue to flow through recorded history. Most of this booze would be in a form commonly called "moonshine."

# WHITE LIGHTNING

In the early Georgia Colony, rum was the predominant distilled spirit—so much so that Governor James Oglethorpe felt the need to control it. Whiskey's influence grew with the increasing number of European settlers, especially

Ulster Scots (Scots-Irish), into all parts of Georgia. Whiskey making was one of the first cottage industries. The American version of this Old World drink depended on a widely used indigenous grain: corn.

Corn whiskey became a staple not only in the Appalachian mountain chain but also all over the South. Rural corn whiskey was clear and of a high proof (high alcohol content). It was clear because it was not barrel aged. Barrels were expensive, and the aging process required storage space and time. Barrel aging whiskey was usually limited to city and suburban distilleries.

Rural farmer-distillers focused on being able to use their entire corn crop, capitalizing on the ease with which whiskey traveled (compared to a wagonload of grain) and the fact that containerized whiskey did not spoil. Further, whiskey was quite valuable as a bartering item, often a more stable currency than cash. Finally, the profit margin of whiskey could be as much as one hundred times higher than corn. The rural distiller's "white whiskey" could be transported in bulk and sold to city rectifiers at considerable profit. Although clear whiskey was a very common item

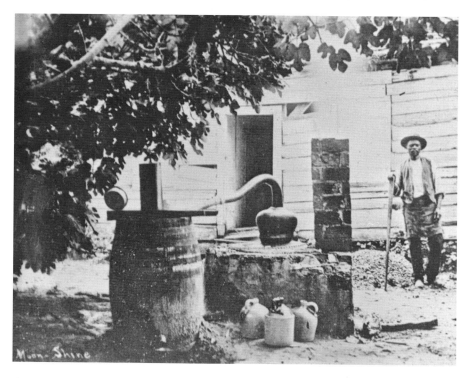

A man standing next to a Georgia moonshine still (circa 1890). *Georgia Archives, Vanishing Georgia Collection, image number geo139-86.*

across the pre-Prohibition southern states, it would become famous from its association with illegal production.

"Moonshine" and "moonshining" are likely two of the most misunderstood alcohol-related terms. To put it simply, "moonshining" is an illegal activity due to license and tax evasion. Distilleries (stills), large or small, commercial or private, have to be licensed by the government and the resulting output taxed accordingly. Illegal distillers do not hold licenses and pay no taxes on their distilled spirits. Prior to the Civil War, the private stills of remote Georgia remained largely undeclared and therefore untaxed. Local distillers were generally viewed in a positive light by their neighbors. Rural communities relied heavily on corn whiskey as a part of "doctoring." Federal government taxation on this local tradition was viewed in an unfavorable light.

In the United States, taxes on alcohol production began in 1791 as a means to pay off Revolutionary War debt. Although these taxes were designed to be fair to all whiskey producers, they favored large distilleries with available operating capital. Whiskey taxes had to be paid in cash, and currency was hard to come by in the rural areas of the South since bartering drove much of the trade.

Sporadic government attempts to enforce the alcohol tax system on unregulated rural distillers (known as "moonshiners") by agents of the Internal Revenue Service (known as "revenuers") was met with firm resistance. The term "moonshiner" refers to the tendency of illegal distilling to occur at night to avoid detection.

The product of illegal stills was called by a bewildering array of names but is most often remembered simply as moonshine. The most

Moonshine in one of its natural habitats: a canning jar. *Ron Smith.*

123

common type was the clear corn whiskey mentioned earlier, though this term also applied to the distillation of mash from apples, peaches, cherries or a combination of grain and fruits. The resulting alcohol was legal (outside the prohibition periods) if properly licensed and taxed. However, the vast majority of rural distilled spirits was made illegally.

At the close of the Civil War, the federal government once again looked to alcohol taxes to ease the war debt. Attempts by Presidents Grant and Hayes to enforce alcohol taxes after the Civil War led to an explosion in violence between moonshiners and revenuers.

## The Georgia Moonshine War

In 1869, Andrew Clark joined the IRS. Assigned to the Second District of Georgia Tax Collection Office in Atlanta, he and his agents were on the front line of the Georgia Moonshine War. The revenue service regularly conducted licensing and tax collection forays into northern Georgia counties. Typically, a party of revenue agents and a collector would travel by train into the area and then ride by horseback into the remote mountainous area. There, they would collect revenue from the licensed stills and destroy illegal (unlicensed and untaxed) stills. Internal Revenue Service agents were paid on commission based on taxes collected, arrests and illegal stills destroyed. According to the book *Northeast Georgia*, by 1876, virtually every case on the docket of the federal court in Atlanta was an alcohol revenue case.

It is an understatement to say that tax enforcement was unpopular with the mountain people. Illegal distillers began to organize and fight back. In one incident, after agents arrested an outlaw distiller during a raid in Towns County, the revenue agents found themselves outnumbered by the equivalent of a local militia. The distiller's family raised an alarm by yelling to neighbors. The neighbors in turn used a series of horns to call the locals to arms. Overwhelmed by superior firepower, the agents had to release the prisoner and flee the area to stay alive.

When revenue agents did make it out of a remote area with their prisoner, often friends and families of the illicit distiller would try to ambush the federal party on the way back to Atlanta in hopes of freeing the captured moonshiner. In a telegraph to revenue collector Andrew Clark, Deputy Collector Hendrix declared that "these counties over the Blue Ridge are in armed rebellion against the government in the enforcement of the revenue laws."

A U.S. Internal Revenue Service special tax stamp to be displayed at a licensed retail liquor dealer's place of business. Note the signature of Andrew Clark, a revenue collector during the Georgia moonshine war. *Collection of Ron Smith.*

Although reinforced with rifles, pistols and shotguns, federal agents were being fired on by armed moonshiners and their families. Several agents and associates were wounded in Georgia shootouts. Responding to the sizable loss in revenue and federal agents being shot at, the president authorized use of the U.S. Army to back the revenue agents. This action dredged up lingering hate from the Civil War as once again federal troops marched into North Georgia.

Resistance from the moonshiners, innocent people being arrested by the U.S. Army and political turmoil in the Georgia legislature against the army troop deployment ultimately led to the withdrawal of federal troops in 1877. However, the conflict lingered. The Ku Klux Klan joined forces with the moonshiners to help combat the revenuers. By the early years of

the twentieth century, violence and the growing influence of the temperance movement had isolated many moonshiners from their local communities. Open conflict was over, but the battles between moonshiners and revenuers would continue.

## Moonshine from 1907 to 1917

During Georgia's state prohibition years, moonshine and all other distilled spirits became illegal. Federal tax collectors were frustrated with the state's prohibition laws. Their duty was to license stills and collect federal taxes. Many revenue agents providing federal liquor licenses to distillers refused to share license information with the state as evidence on which the retailer would be convicted under state law. The prohibitionists were infuriated with this withholding of evidence, which seemed to defy the state laws.

*Shaping the 18th Amendment* highlights a particular clash between federal officials and the state prohibition law in 1909. The Cureton Distillery in Rising Fawn was operating despite the prohibition law. It had followed all federal alcohol laws, which meant that a federal official "gauged" the amount of alcohol produced. When the federal gauger refused to testify against the distillery, a local judge had him incarcerated. The official's boss (located in Atlanta) sent a telegram to the incarcerated man telling him that the district attorney advised him not to testify. Upon reading this telegram, the judge ruled the federal boss in contempt of court and had him arrested by the sheriff of Fulton County.

During an Associated Press interview, the judge pointed to the injustice of a federal officer aiding and abetting a "wildcat distillery" in the dry state of Georgia. The federal gauger was ultimately released from jail, and his Atlanta-based boss was released on the threat of a U.S. Army cavalry troop being sent to remove him from jail. Member of the Georgia Assembly and temperance leader Seaborn Wright used this incident as an example of diminished state's rights and called for a restructuring of the federal government's policy toward dry states.

While federal and state governments faced off over alcohol law, moonshine (also called blockade corn) flowed like a river into Atlanta. "Trippers," those who transported illegal alcohol to illicit buyers, drove wagons and eventually automobiles into the city to sell their cargo. Subsequently, people like Dan Shaw, Hub Talley and other semi-organized gangs wholesaled it to blind tigers or sold it in larger quantities to those who could afford to buy.

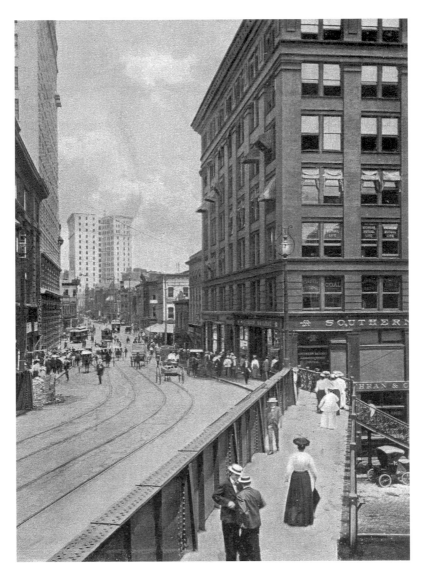

Atlanta viaducts, early 1900s. Trippers would deliver their moonshine to secluded areas beneath the viaducts. Raphael Tuck & Sons postcard. *Collection of Ron Smith.*

Performer-composer Perry Bradford supports this point in *The Devil's Music,* where he indicates that Courtland Street's vice was operated by a white gang, while Decatur Street was run by a black gang. Bradford talks of several Decatur Street locations where a knowledgeable person could get a "belly-full of corn whiskey." Bluesman Tom Dorsey recalls in *The*

*Voice of the Blues* that "the town went dry and those country men would come in town and bring the bootleg liquor, and people had these parties together. Especially up and down Decatur Street, which was kind of a sporting district anyway."

## Tripping During National Prohibition

With the passage of the Eighteenth Amendment, federal revenue agents, as well as state and local law enforcement, at the very least had the common goal of prohibition enforcement. What complicated achieving this goal was the lack of a legal definition of "concurrent enforcement" between federal and local law agents. Further, funding allocated for prohibition enforcement was appallingly low at all levels of government. Despite these challenges, the federal Prohibition director was quoted in 1922 in the *Atlanta Constitution* as stating that more illegal stills had been destroyed in Georgia than in any other state.

Once automobiles came on the scene, tripping transitioned from farm cart to motorized car. Tripping had really taken hold with national Prohibition. In the 1920s, a hauler could make enough money on one moonshine run to buy a new Model A Ford. The runs were so profitable that haulers figured they could abandon one out of every three cars to the law and still be ahead.

The dirt roads from Dawsonville to Atlanta were the birthing grounds of NASCAR, but the back story is in the strength of the trade route. For a period of time, Dawsonville was the national moonshine capital. Brave drivers would load up and wait until nightfall to drive to Atlanta, then clean up their cars and do early morning drop-offs.

As Dabney describes in his book *Mountain Spirits*, "Down the kinky, narrow roads into Atlanta rolled a seemingly unending convoy of steel rear-spring Ford coupes, each loaded with around a thousand pounds of white lightning, encased either in one-gallon tin cans, five to an onion sack; or in half-gallon Ball jar, twelve to a six-gallon corrugated case." All this was going on when Dawsonville had only one telephone, a pay phone at a service station. Interested buyers could place a phone call to that telephone and ask in code, for example, whether peaches were in stock.

Trippers took their cars quite seriously because the ability to conceal liquor and move it faster than the law was paramount. During the height of Prohibition, a 1929 Chevrolet touring car could be modified into a liquor trip car with a false backseat hiding a storage area that could conceal 125

*Above*: The former Harben Brothers Service Station in Dawsonville, Georgia. Moonshine trippers hung out near the station's pay phone, waiting for moonshine orders to deliver to Atlanta. *Ron Smith.*

*Right*: Dwight Bearden, distiller at the Dawsonville Moonshine Distillery and fourth-generation moonshiner, standing next to a still he helped build as a young man. *Ron Smith.*

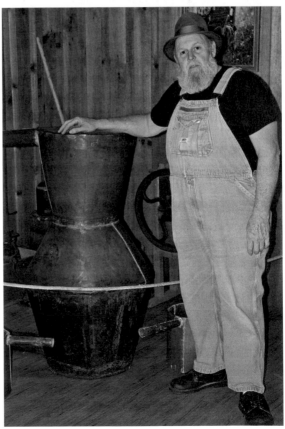

to 135 gallons. Liquor runners would gather along U.S. Highway 41 from Atlanta to Marietta to show off their modified cars.

Much of the liquor coming from northeast Georgia, especially Dawsonville or Dahlonega, came down State Highway 9, which is now U.S. Route 19/ Roswell Road. A common route into Atlanta was off 9 South onto Piedmont Road, which at the time was narrow and twisting. Running was not for the faint of heart. Most drivers coming into Atlanta in the 1930s and early '40s were not driving on pavement until they reached the outskirts of the city. If drivers were being chased on main roads, they would turn onto dirt roads that they knew well.

Trippers modified their vehicles for efficiency and speed, but they were not the only ones to adapt. State revenuers sometimes spot-welded heavy ninety-pound rails on the frames of their cars to bump the liquor trippers. State agents claimed to have disabled fourteen new liquor cars in one month in 1937.

Law enforcers also learned what to look for to spot trip cars. Fulton County policemen patrolled the main roads into Atlanta and always watched for cars that bounced stiffly (because cars on stiff springs running empty would bounce a lot). The police learned to be as fearless as the drivers. One chase by officer Burton Carroll after a moonshine car turned into a sixty-mile-per-hour race around the statue of Henry Grady.

Stories by ex-trippers indicate that they started young and bold. One tripper started transporting his grandfather's illegal whiskey in 1935 at the ripe age of fifteen. His first load was hauled in the back of a Model A Ford truck, driven to Kennesaw uncovered in broad daylight. Another former runner believes he ran one thousand loads of whiskey into Atlanta during his five-year career, also starting at fifteen years of age. He would discreetly haul an average of two hundred gallons on each trip: "I'd go into Atlanta nice and quiet and easy, like you was going to mass."

## After Repeal

Repeal of the Eighteenth Amendment in 1933 and repeal of Georgia's bone-dry law in 1938 did little to slow the flow of white lightning into Atlanta—or for that matter, any county wet or dry. The state had developed a taste for blockade corn during the Prohibition years. The 1940s and '50s saw plenty of moonshine arrests. What changed were the economic status of the clientele and the nature of the drink itself. With reinstatement of the

legal liquor market, stabilization of legal prices and more Georgia counties going wet, moonshine became the drink of poverty.

Now, after the tripper dropped off a load, bootleggers (the term "blind tiger" fell out of use) would split the hooch into three-ounce portions to be sold in baby food jars. The norm became shot houses and "nip joints," where customers were sold three-ounce shots of white whiskey for one dollar. By the early 1970s, the moonshine tripping days were winding down. In his book *Mountain Spirits*, Joseph Dabney states that 1940s haulers ran about fifty thousand gallons of untaxed whiskey into Atlanta each week. By the early 1970s, the estimated volume had dropped to eight thousand gallons a week.

One reason for the decline was what Dabney refers to as *metro moonshine*, or distilling taking place in metro areas as opposed to being hauled in from rural areas. He notes that in 1974, shot house operators were making an estimated untaxed $700,000 per month. Operators would gladly pay fines up to $300 for possession of untaxed whiskey (usually a misdemeanor). This metro moonshine was made from pure sugar with no grain added and was distilled in non-copper stills, often using items like a car radiator. This noxious "sugar jack" was, like the bathtub gin of Prohibition, made to mix with other liquids to kill the flavor. Most of this metro moonshine also contained metallic salts, which over time and repeated consumption could cause serious physical issues.

The producers' lack of distillation engineering knowledge was not limited to metallic salts. In 1951, a notorious case of alcohol poisoning in Atlanta nightclubs involved at least forty victims. The illegal moonshine was purchased from a metro bootlegger named John "Fat" Hardy. One fateful batch of his moonshine was fortified with methyl alcohol he had purchased from a drug wholesaler. At least thirty-five people died in a week, and many others were left blind and paralyzed. A locally famous blues song, "Fats Hardy Tardy," was written by Tommy Brown about the incident. Gospel group Echoes of Zion also produced the song "Atlanta's Tragic Monday" related to the event.

Moonshine tripping from Dawsonville may be a thing of the past, but illegal moonshine is not. In the 1980s and '90s, an occasional urban moonshine still blew up, damaging the building in which it was housed. As recently as 2004, moonshine made headlines in *Emory* magazine. Brent Morgan, assistant professor of emergency medicine at the Emory School of Medicine, began a moonshine study after four patients showed up at Grady Hospital with lead poisoning. Some participants said they got their moonshine in Atlanta, while others procured it elsewhere in Georgia.

## RUMRUNNING AND THE DIXIE HIGHWAY

Starting in 1915, a series of roads was constructed to provide a continuous highway to and from the South. This system, known as the Dixie Highway, took motorists to the northern states and the edge of the Midwest. This early interstate project allowed many Americans to travel farther and faster than ever before. An unintended consequence was its value as a north–south bootlegging route.

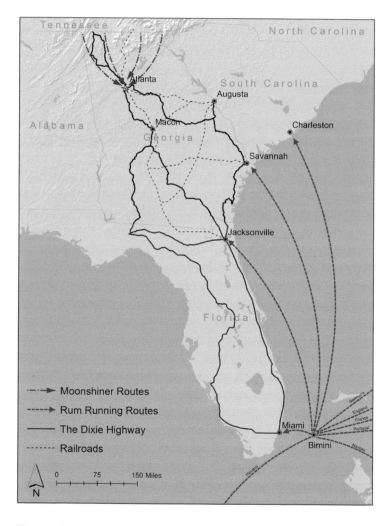

The Alcohol Trail. Liquor moved into and through Atlanta via moonshine tripping, the Dixie Highway and railcar shipments. *Map by Matthew Tankersley and Josh Blackmon.*

In 1921, a correspondent for the *Atlanta Constitution* called the Dixie Highway the nation's Alcohol Trail. He stated that during Prohibition, more alcohol was smuggled into the United States through Bimini and the Bahamas than anywhere else. From these locales, a flood of European alcohol and some previously exported pre-Prohibition American booze made its way up the eastern seaboard. In the same year, former secretary of state William Jennings Bryan threatened to use his influence to persuade the United States to purchase or forcefully annex Bimini if the island continued to be used as a rumrunning base. (Although the term "rumrunning" was commonly used, alcohol of all varieties was being smuggled into the country.)

Legal European alcohol arrived to the islands and was then distributed among fast, light rumrunning boats. Once inside U.S. waters (then three miles from land), the alcohol became illegal. The entrepreneurial crews of these boats bundled the bottles of gin, whiskey, scotch, wine and various other libations into burlap bags with cork floats. Pulling as close as possible to shore, the crews tossed the bags into the ocean at a designated drop point.

A land-based crew would either wade or row out in a small boat to retrieve the floating cargo. The retrieved alcohol was transferred to waiting cars. Some bootleggers had purchased houses and farms near the shoreline to temporarily store the illegal alcohol before it began its northbound trip. Ultimately, the hooch found its way out of the area in disguised crates in railcars or personal vehicles headed up the Dixie Highway. Bootlegger-owned or otherwise friendly houses and farms along the Dixie Highway acted as safe houses and rest stops for the drivers. Although much of the illegal cargo was destined for northern speakeasies, Atlanta provided a sizable southern customer base along the way.

As the Dixie Highway approached Atlanta, it was known as Stewart Avenue (now Metropolitan Parkway Southwest) and portions of this road have hosted illegal activities for nearly a century. Although many bootlegging arrests were made along this stretch of the Dixie Highway, three cases reported in local papers stand out. In May 1920, a car was seized on Stewart Avenue with ten gallons of whiskey and a two-foot alligator. In March 1928, over 200 quarts of whiskey bound in sacks were seized from a touring car on the same road. The sacks were still wet with seawater and covered with beach sand. Upon questioning, one suspect indicated that the sacks came from a Florida port and that he had been hired by a stranger to drive the liquor to Atlanta. On November 9, 1929, a woman in a coupe hauling 150 quarts of whiskey was chased by police from Hapeville to downtown. Reaching Atlanta, the chase left Stewart Avenue and wove through several downtown

streets, where the lady lost control of her car and crashed. She fled on foot, evading police to escape arrest.

With the repeal of national Prohibition, wholesale rumrunning and its associated Dixie Highway bootlegging dried up, leaving behind regional moonshine trippers and legal alcohol sales. Even now, the rusting hulks of wrecked ships dot the coast of the island of Bimini as a testament to the profitable business of quenching American thirst during Prohibition.

Chapter 9

# SOCIETY DEMANDS REPEAL

*Post-Prohibition you were picking up the pieces and trying to find a new moral framework for improving America without quite so much pride and arrogance and self-assurance as the prohibitionists had.*
*—Martin Marty, theologian,* Prohibition, *2011*

The Eighteenth Amendment was eventually defeated by the collective frustration of the American people, the need for increased tax revenue, jobs required during the Great Depression and a general shift in society. Wet-minded people were tired of secretly making their own booze or purchasing poor-quality alcohol of questionable origin at a high markup. In some cases, blind tiger alcohol was lethal. Deaths by wood alcohol ingestion were reported in Atlanta in 1919 but were likely occurring at an earlier time. One of the most dangerous brands of Prohibition hooch, Jamaica Ginger (aka Jakey), was sold in Atlanta and put several people in the hospital. Dry-minded people were exasperated that law enforcement officials could not stop the selling of illegal alcohol. The legal system was flooded with Prohibition cases, and juries lacked interest in prosecuting offenders. Violence related to Prohibition was of concern to both sides.

A Prohibition parody of *Spirit of '76*. "Jakey" is slang for Jamaica Ginger, a notorious Prohibition-era patent medication. *Collection of Ron Smith.*

## AMERICAN SOCIAL RENAISSANCE

Society was undergoing dramatic changes. This social renaissance was fueled by urbanization, technology and women's liberation. By 1920, for the first time in the nation's history, the majority of Americans lived in urban environments. Prohibition continued as a battle between socially diverse urban and traditional rural areas. The countryside continued to be dominated by white Protestants, who viewed themselves as the last bastion of the puritanical Christian values of thrift, hard work and self-denial. However, the siren's song of the dollar lured rural farmers to trade with the city folk, and it increasingly drew rural youths to jobs and education offered in these urban areas.

Despite tough conditions in urban southern factories, changes like electricity, mechanical advances and the shorter workweek allowed most people to have enough time and money to spend a little on something beyond life's necessities. In *Living Atlanta*, country musician Marion Brown recounts his memories of blind tigers in Cabbagetown: "Yeah, there was half a dozen right around in that neighborhood because when all them mill people got out, man they headed for a bootlegger…They wanted to get them a drink when they got out of that dusty cotton mill."

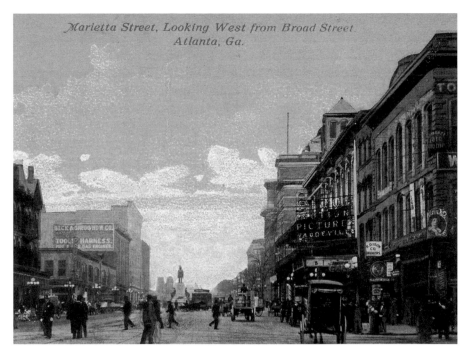

Marietta Street viewed from Five Points in 1911. The Bijou Theater (right) hosted vaudeville acts and prohibition speakers. *Collection of Ron Smith.*

Drinking was not the only entertainment the urban working class sought out. Moving pictures, vaudeville shows, music and sporting events were increasingly popular. Shirking the Victorian notion of fun equals sin and spurred on by a boom in advertising, young city dwellers developed an insatiable thirst for amusement. The routine of the workweek demanded an escape. Entertainment became the factor that connected a nation divided by race, class and ethnicity. Americans were collectively looking to "get out of the house."

Technology made getting out far easier. Instead of saddling up the horse or hitching the buggy, city dwellers and suburbanites were using the streetcars, taxis or, increasingly, their automobiles. People could travel greater distances in shorter times to be entertained. The same technology also made it easier for illegal alcohol to travel to the urban masses, keeping them hydrated during leisure time.

## Dance and Drink on Decatur Street

Greater free time, mobility and especially spending cash led to the business of public-accessible clubs. In early 1900s Atlanta, theaters operated like early nightclubs. Other than motion pictures, they offered vaudeville acts, dancing girls, comedians, animal acts (beyond the blind tiger) and noted musicians and singers. While the more civilized entertainment happened on Peachtree Street and Auburn Avenue, Decatur Street maintained its sporting status.

Decatur Street's Bailey's 81 and 91 Theaters paved the way for well-known Auburn Street social spots like the Top Hat Club (later the Royal Peacock) in 1938 and Club Poinciana in 1944. This area hosted many famous African American entertainers such as Bessie Smith, Ma Rainey, Tom Dorsey, Cab Calloway and Blind Willie McTell. Decatur Street became Atlanta's version of Memphis's Beale Street. Blues music of several varieties, ragtime and jazz all influenced Atlanta's nightlife through the years. One form common to Decatur Street was "barrelhouse blues." This music style was named for the

A contemporary photo of the Royal Peacock (formerly the Top Hat Club) on Auburn Street. *Ron Smith.*

small gathering places where a barrel of illegal beer was placed in the room and shared by patrons while listening to music.

Clubs that hosted live music did more for racial integration than any other institution. Atlanta whites were beginning to take an interest in black music, most notably jazz. White couples in Atlanta were also beginning to frequent nightclubs that were primarily known as bastions of black entertainment, although on a strictly segregated basis. According to *African-American Entertainment in Atlanta*, Baileys 81 Theater on Decatur Street had special nights for white audiences.

Described in 1920s local newspapers by the chaste white evangelicals as "demoralizing, wicked and the devil's music," jazz was blamed for hypnotizing youth and destroying marriages. These evangelicals linked the wickedness of jazz directly to anti-prohibitionists, who supported repeal and the legalization of beer and light wines. Once again at the core of this fervor was the aversion to race integration, especially in dance halls or private parties where illegal booze consumption was known to occur.

## Giving It the Good Ol' College Try

Young people of college age made drinking fashionable across the nation. Prior to the 1920s, any southern girl of "good family" would have been horrified to be offered a drink in a public setting. Thanks to Prohibition, by the 1920s, low-key drinking was not uncommon at dances and football games.

Atlanta's *Sunday Constitution* magazine published a nationally syndicated article in January 1922, laying out the perceived immoralities of modern college life: "For Many Students It Is the Hip Flask, 'Petting' Parties, 'Pash' Garters and Perfume, Wild Music and the Camel-Walk, Rather Than Books and Study." This article and others like it demonstrate two important factors. First, national trends (youth fashion, dance and societal change) were starting to affect Atlanta; second, illegal drinking was trendy.

America's youth, especially college students, had become contemptuous of the self-righteous moralists of the preceding two generations. They saw Prohibition as the government invading the privacy of others. Atlanta residents and college students may have attended occasional parties, with dancing or without, where a hip flask was being passed around, but the modern concept of the Roaring Twenties as a scene where every American danced the Charleston in a speakeasy and drank until the break of dawn is a myth. Most of the speakeasy culture occurred in the

A 1922 *Atlanta Constitution* image warns (or entices): "Lips that touch liquor shall never touch mine, but confectioners' bonbons ofttimes conceal wine." *Courtesy of www.Fold3.com.*

largest northeastern cities, and the total number of patrons was a small percentage of the population.

There is some truth to the decade's image of decadence and prosperity, but the wealth was concentrated at the top. Only the rich could afford the brand-name liquor in speakeasies; drinks of that caliber were a status symbol. In the South, speakeasies and the cocktail hour were unknown to the majority of folks. Most people drank home brew in the privacy of their homes, partied in friends' homes or bought cheap "corn likker" from blind tigers to take out to dances or football games.

## WOMEN'S SUFFRAGE

The Nineteenth Amendment, ratified in August 1920, gave women the right to vote. Lobbying for women's suffrage and the passing of this important amendment would have taken much longer if not for the Woman's Christian Temperance Union. The suffrage movement leading to the amendment gained a standing army of supporters directly from the WCTU. Women like Frances Willard and Elizabeth Cady Stanton played major roles in both the temperance and suffrage movements. Wets were mostly against women's suffrage. Their logic was based on sixty years of the anti-alcohol attitudes of most Protestant Evangelical women. In 1917, the *American Brewers' Review* stated, "While the belief that women voters for the most part are temperance crusaders has been challenged, a study of election results in states where women already have the vote…upholds this belief."

Female voters in the 1930s would leave both the Drys and Wets dumbstruck. The sisterhood of the temperance movement, the suffrage cause and many other progressive causes gave women the courage to press forward for a more equal place in society. The daughters and granddaughters of Victorian-era women inherited this new, vastly expanded sense of social place. However, women of the 1920s and '30s did not share their forebears' sensibilities on many topics. The differences included work, fashion, relationships, drinking and entertainment. Many women of this generation struck a new path and forever changed the dynamic of society.

Thanks to World War I and progressive movements, the 1920s and '30s saw a dramatic increase of white women in the workforce. African American women working predominantly in the field of domestic help had occupied the workforce since emancipation. On Auburn Street during this time, there were several black female business owners. Like their male counterparts, these ladies wanted to experience some entertainment after a boring, challenging or downright hostile workweek. This led workingwomen to private parties and dance halls for relaxation and social interaction.

Religious Protestant fundamentalists tried to fight women who drank, smoked and wore short skirts. They resisted dance halls and the movie houses, where more and more frequently unescorted young women were meeting their boyfriends.

## WOMEN'S ORGANIZATION FOR NATIONAL PROHIBITION REFORM (WONPR)

Pauline Sabin founded and led the Women's Organization for National Prohibition Reform (WONPR) in 1929. Earlier in life she had been a staunch supporter of national Prohibition. As with many Americans, her opinion on the matter slowly changed. She came to realize that the

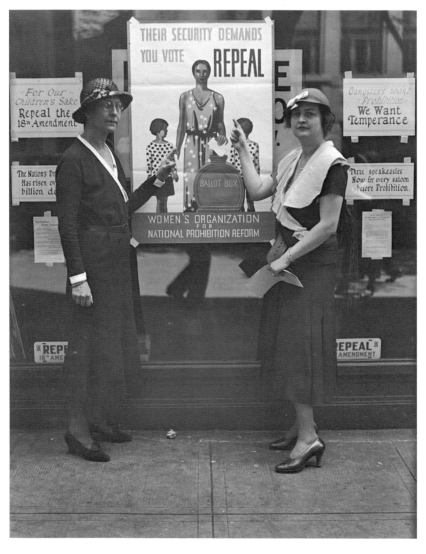

Supporters of the Women's Organization for National Prohibition Reform in 1932. *Library of Congress.*

Eighteenth Amendment was not only ineffective and counterproductive but was also an underlying cause of violent organized crime. She was active in Washington, D.C. politics and hailed from a respected business family. As head of WONPR, she became the elegant, sophisticated, educated and even fashionable face of Prohibition repeal. She became the "Frances Willard" of the Prohibition reform cause. Young women admired her, and Sabin's professional manner won over many supporters. The organization had 1.1 million female members in 1932, growing to 1.5 million in 1933.

The WCTU and those of similar mind had assumed that all American women, once given the right to vote, would vote dry. What they did not count on was the dramatic change in society from 1919 to 1933. The platform of home protection and the perceived higher moral standard of women in society were simply overcome by events. The WCTU was not equipped to fight woman to woman on the issue of Prohibition repeal for protection of the home. The Prohibition women were especially enraged that the WONPR was using nearly identical imagery, campaign strategies and political tactics that they had employed decades earlier.

Drys were so narrowly focused that they were shocked to learn women would want to drink in public. In their eyes, it reduced women to the level of men. Women, once placed on a high moral platform, were jumping down of their own volition and joining working-class America like never before. All of these women—regardless of race, creed or religion—could now vote.

## THE ROAD TO THE TWENTY-FIRST AMENDMENT

In the 1920s, the Drys repeatedly pointed out that national prosperity was due to Prohibition. When the economy crashed leading to the Great Depression in the 1930s, that platform tie-in backfired. The upper class's lavish spending in the Roaring Twenties now seemed obscene. Speakeasies fell into that category of unrestrained extravagance. During a national depression, alcohol was still flowing, and every drop was untaxed. Society bore the cost of policing and prosecuting the overwhelming number of offenders.

Violators were so numerous that it became a national joke. The term "scofflaw" arose from a 1924 *Boston Herald* competition to describe a person who defied Prohibition by drinking illegally. Arguably, America had become a nation of scofflaws. Where temperance groups had earlier put their sociopolitical spin on prohibition and the saloon, now anti-prohibitionists

put their spin on the speakeasy. It appeared that alcohol was more a social issue than the perceived moral issue. *Collier's* magazine conducted a survey in 1925 and determined that Atlanta was the wettest city in the nation. This was determined by the perception of each city's residents of how wet or dry the city was. It is doubtful that Atlanta holds this title nationally, but by all indications, it was the wettest in the South.

## Roosevelt and Atlanta 3.2 Beer

In an attempt to lift the spirits of the American people during the growing economic crisis, and hoping to strike a balance between Wets and Drys, President Roosevelt signed the Cullen-Harrison Act on March 22, 1933. This act modified the Volstead Act, allowing for 3.2 percent ABW beer (alcohol by weight or roughly 4.0 percent alcohol by volume). At this time, 3.2 percent beer was considered to be "nonintoxicating." The act went into effect on April 7 of that year.

On May 19, Atlanta's Mayor Key signed an ordinance allowing 3.2 percent beer. This was a bold move, as Georgia's bone-dry law did not allow any beverage alcohol. Governor Eugene Talmadge indicated there was nothing he could do to prevent the sale of beer since he did not appoint mayors or sheriffs. Atlanta licenses began to be issued for "nonintoxicating" beer immediately, although a new definition for this term had not legally been set in the state. An investigation by the United Press found that much of the beer was being produced by the Atlanta Ice and Bottling Company, possibly preceding the change in local law and in contradiction to state law.

Shortly after this measure was put into place, outside beer did not have an easy time getting into the city. Various county sheriffs were seizing the beer headed to the city, and bootleggers were hijacking the trucks. Ten days later (May 29), the state court of appeals ruled that 3.2 percent beer was illegal via state prohibition law. The ruling was based on a case in Rome, Georgia, where it was decided that if the item "smells like beer, tastes like beer, and has the color and general appearance of beer," then state prohibition rendered it illegal.

Atlanta's mayor protested the ruling. Local federal liquor tax collector W.E. Page stated in the *Thompsonville Times-Enterprise* that all he was concerned with was collection of the beer stamp tax, not local politics. Yet the federal tax issuing agency in Washington, D.C., withheld further beer tax stamps from the Atlanta Ice and Bottling Company until clarification of the issue could be reached.

In October of the same year, Illinois' *Freeport Journal-Standard* noted that the passage of the Cullen-Harrison Act had made Atlanta a confusing place. By state law, beer was illegal; by U.S. congressional law, 3.2 percent beer was legal; and by the newly passed Atlanta city ordinance, beer was quasi-legal. Over two hundred locations in Atlanta were selling beer during this confusion; when a few operators were arrested by state prohibition officers, jurors refused to convict the sellers in court.

## Repeal of National Prohibition

Repeal became imminent after the efforts of the WONPR and other grass-roots anti-prohibition lobbying groups changed the tide of American sentiment. Driven by this political movement, Congress formally passed a proposal in February 1933 to repeal the Eighteenth Amendment. The federal government chose to ratify repeal by state conventions (not state legislature). The powerful lobbying machine of the Anti-Saloon League was still intact, and congressmen, not to mention many of the citizenry, feared that the lawmakers of many states were bought by or bent to the temperance lobby.

State conventions were held to consider the new amendment. After a surprisingly quick eight months, the State of Utah became the thirty-sixth state to ratify the Twenty-first Amendment, meeting the requirement to officially repeal federal Prohibition. Repeal became official on December 15. The Eighteenth Amendment would go down in history as the only U.S. constitutional amendment ever repealed and the Twenty-first Amendment as the only amendment passed by state conventions. Georgia is one of eight states that took no action to repeal national Prohibition.

This is the point where many history texts and videos claim that the American public could legally partake of beverage alcohol. That was not actually the case, especially in bone-dry southern states. Over half of United States territory remained partially or completely dry after December 1933. Georgia had already shown its willingness to prosecute 3.2 percent beer cases, and section two of the new amendment had returned power to the states to regulate beverage alcohol.

# THE LONG ROAD TO GEORGIA REPEAL

As the nation was repealing the Eighteenth Amendment, the Georgia WCTU was holding its fifty-year anniversary in Augusta. The powerful lobbying machine of the Georgia Anti-Saloon League and the state WCTU was intact. Legislative alcohol prohibition had come about largely through the efforts of the ASL influencing close elections. This tactic and raising money at revivals and other speaking opportunities continued to favor dry policies in Georgia.

The renewed battle over state prohibition was a familiar one between cities and rural areas. The highly conservative rural areas were dry strongholds, while wet-minded cities such as Savannah and Atlanta struggled to loosen the grip of rural voters. If the 1918 state prohibition law (the bone-dry law) could be repealed, then the state could return to local option voting.

Into 1934, the fight was focused mainly on the legality of 3.2 beer. As stated earlier, Atlanta's mayor signed an ordinance to allow 3.2 percent beer on May 19, 1933, shortly after President Roosevelt modified the Volstead Act. This city ordinance flew in the face of the bone-dry law. An Atlanta clergyman called the Atlanta 3.2 beer ordinance "a crime without parallel in the 200 years of Georgia history." This was not the first time Mayor Key had caused uproar. Attending a 1931 convention of U.S. mayors in Paris, France, Key spoke out publically against Prohibition and the Eighteenth Amendment. Upon his return to Atlanta, he was forced to step down as Bible study teacher at his church and found himself subject to a mayoral recall vote. Much to the surprise of the Drys, he soundly defeated the recall.

Atlanta's "beer joints" were thriving. A Fulton County petition of two thousand signatures in support of 3.2 beer was signed in April 1933. Sandwich shops (the only location with a long bar-like counter) and small grocery stores were popular places to purchase beer. Atkins Park Delicatessen (later Atkins Park Tavern) and Harry's Delicatessen, which would ultimately become Manuel's Tavern, were two of many beer joints and would later become historic Atlanta destinations.

In 1935, after a failed attempt to repeal Georgia's bone-dry stance, Governor Talmadge agreed to sign a bill modifying the law to allow beer and light Georgia-made wines. After two years of ambiguity, a clearer state law was finally on the books. The Atlanta Ice and Bottling Company—bottling local soft drinks, marketing nonalcoholic cereal beverages and likely producing beer on the sly—briefly produced legal beer before being bought by the Atlantic Ice and Coal Company. Reorganized under the Atlantic Company

A State of Georgia two-cent beer tax stamp, circa 1940s. *Collection of Ron Smith.*

A choir sings in the chamber of the Georgia House of Representatives during a 1937 attempt to repeal the bone-dry law. Lane Brothers Collection. *Courtesy of the Special Collections and Archives, Georgia State University Library.*

umbrella, Atlanta's hometown brewery operated until 1955, when it was outcompeted by consolidated national breweries. Three attempts at opening other breweries failed during this legally ambiguous period. Liberty Brewing, South Atlanta Brewing and Southern States Brewing tried to charter businesses in the Atlanta area in 1933, but the state's delay in officially approving legal beer rendered the concept infeasible. The Georgia wine industry made a cautious start after 1935, but beverages containing distilled alcohol remained illegal (in other words, the province of bootleggers and blind tigers).

ACCORDING TO *LIVING ATLANTA*, an investigation of the Atlanta and Fulton County police departments in 1937 revealed that 40 percent of the surveyed departments were involved in arranged profit sharing with bootleggers.

Under the leadership of the Georgia Hotel Association, Wets began a campaign to repeal the state's prohibition law. In opposition, the Drys formed the Consolidated Forces for Prohibition in Georgia. This coalition included the Georgia ASL, the WCTU, the Allied Youth and a network of Protestant churches.

In 1937, two bills sought to return legal distilled spirits to the state. The Hastings bill proposed to return Georgia to a local option system. The other proposed a state-operated dispensary system. This time around, Drys fought to keep local option or a dispensary system out of the Georgia legal system. They were aware that public sentiment had changed in the cities and the moderately populated portions of the state. Both wet and dry leaders spoke before the Georgia House in a bitter debate. Drys packed the gallery, and a church choir sang during a break in the debate. The Drys won a stay on the decision, and neither bill went forward.

State prohibition was revisited in early 1938 with the Georgia state senate passing a bill favoring local option. On February 2, in the same chamber that saw a fistfight in favor of prohibition, the Georgia House of Representatives voted 105 to 85 to undo the last remnants of Georgia's bone-dry law. The two female members of the assembly voted in favor of the bill. By adopting the senate's substitution liquor bill, Georgia was on the cusp of returning to local option, allowing each county to decide by popular vote its methods for alcohol regulation.

Attempts at amendment by the Drys had failed. They declared that the Wets were "trying to ram alcohol down the throats of the dry counties." Floor leader Clement Sutton was more succinct in his assessment: "The cause is lost." The leader of the Georgia ASL was in the gallery for the vote. While in 1907 his constituents had yelled to throw the speaker over the railing, this time he merely smiled and walked out.

The following day, Governor Rivers signed the liquor tax bill legalizing distilled beverages in Georgia for the first time in nearly a quarter century. The citizens of Fulton County voted wet by a sweeping 76 percent majority on March 30, 1938. Legal sales in Atlanta resumed less than a month later. One-half pint was the smallest amount that could be legally sold. State law

The chamber of the Georgia House of Representatives. Many prohibition bills passed through this room, which also hosted a famous mid-session fistfight. *Ron Smith.*

required patrons of the liquor stores to sign their names to buy distilled spirits. Perhaps to poke at lawmakers, many people chose to sign as the governor or the revenue commissioner.

You would think, at this point, that anyone could enjoy a bit of alcohol free of politics and legal restrictions. However, deep-rooted biases held strong in rural areas, and battles in mainly dry counties continued for decades.

## Chapter 10

# PROHIBITION'S LEGACY

*The businesses of manufacturing, distributing, selling, handling, and otherwise dealing in or possessing alcoholic beverages are declared to be privileges in this state and not rights.*
—Official Code of Georgia Annotated 3-3-1, *2010*

## POST-REPEAL CONTROL OF ALCOHOL

The study *Social and Economic Control of Alcohol* outlines that post-repeal America was concerned with three main goals related to alcohol control: eliminate bootlegging, eliminate the speakeasy/blind tiger and prevent the return of the saloon or tied house. Even President Roosevelt stated, "I ask especially that no State shall by law or otherwise authorize the return of the saloon either in its old form or in some modern guise." It would not be a federal issue, as section two of the Twenty-first Amendment gave the states virtually unlimited control of beverage alcohol.

To achieve control of alcohol while simultaneously maintaining or increasing tax revenue, the states looked for guidance in the 1933 analysis *Toward Liquor Control.* This study advocated a three-tiered system of government control. The beverage alcohol industry was divided into three categories: producers (breweries, distilleries and wineries); wholesalers and distributors; and retailers. Businesses in this model occupy no more than one

tier of the system, eliminating the possibility of a tied house. This model also allows a broader base of licensing and taxation for the government.

State prohibition may have been defeated in Georgia, but county local option laws were still in place. As the wet portions of the state adjusted to the three-tiered system, many areas remained dry. This would continue in some form through most of the last century. Illegality of Sunday sales was strongly enforced across most of the state until a vote in 2011. Many communities still retain some portion of the Sunday laws (blue laws) or other restrictions that were enacted by the prohibition movement in the late 1800s or early 1900s.

Even in the wet cities and counties, the theology of the prohibition movement, especially its mandatory classroom instruction, had left a lasting legacy. Average citizens wanting alcohol to cook with or to drink in the comfort of home could venture to a "bottle shop" or "package store." There they would emerge with a package, a brown paper bag, the true contents hidden. These names reflect the uneasy truce between the newly liberated Wets and "polite society" (the defeated Drys), who did not want to see the bottles and cans. Legal suasion had been moderated, but moral suasion remained. The Drys wanted beverage alcohol distanced as far as possible from society—out of sight and out of mind, in a manner strangely reminiscent of blind tigers.

## CONTEMPORARY GOVERNANCE OF ALCOHOL

In respect to tied houses and large-scale bootlegging, laws formed around the three-tiered system have been successful for over eighty years. What this structure could not predict was market evolution in the American economic system. The twenty-first century is a vastly different economic environment than that of the pre-Prohibition period. From the mid-twentieth century to the current day, the beverage alcohol industry has seen a tremendous trend toward consolidation. By the late 1970s, only eighty-nine breweries produced all domestic beer, with the vast majority produced by only three players.

The distillation industry saw amassing as well, with most brand names owned by a few companies in England, Japan and Italy. Further, the modern alcohol industry is experiencing a globalization trend. This is true not only of alcohol producers but also of wholesalers and national and global retail chains (hotels, restaurants and clubs). *Social and Economic Control of Alcohol* and similar studies state that one of the greatest concerns about the modern three-tiered system is the monetary influence these

consolidated mega-corporations wield, especially on state wholesalers and wholesaler unions.

Ironically, a powerful regulating aspect of the modern-day three-tier structure is neither government nor big business but the consumer's quest for product variety. By desiring products such as craft beer, small-batch distilled spirits and locally produced wines, American consumers have begun to shift the market away from large international conglomerates whose management may be distant and unreachable. Fostering the locally produced beverage alcohol market supports local and regional commerce while returning a margin of control to the state and community. With the ability of law enforcement to literally knock on the door of small distillers and brewers—whose businesses depend on the local community—there is more communication and mutual respect.

## THE POST-PROHIBITION BAR

Like its predecessor the saloon, the modern bar is viewed as the standard interface between the public and alcohol. However, the contemporary bar is a complex crossroads of many prohibition-influenced factors. These include beverage alcohol, women's suffrage and race relations.

Saloons, which became the scapegoat of the prohibition movement, did reflect fundamental disparities in society. From a gender standpoint, they were almost exclusively male forums and, in being so, pulled men away from their families. From a racial standpoint, saloons were clearly segregated for black and white patrons. An unexpected outcome of prohibition is a resetting of the drinking establishment to represent a broader spectrum of society.

The suffrage movement was accelerated by the women of the WCTU. Their daughters in turn became bolder women who stormed male-dominated bastions like the saloon—not to shut them down but to drink beside men during leisure time. The Hollywood image of the flapper in the speakeasy had done much for women entering the public drinking sphere, but reality was much slower and more cautious. The repeal decade of the 1930s saw a furtherance of women's preference to drink at home, and the development of take-it-and-go beverage alcohol outlets promoted consumption at home.

These factors spawned the home cocktail party of the 1930s–'50s. The cocktail party among young to middle-aged couples presented a controlled aspect of beverage alcohol drinking. It also primed southern women to enter

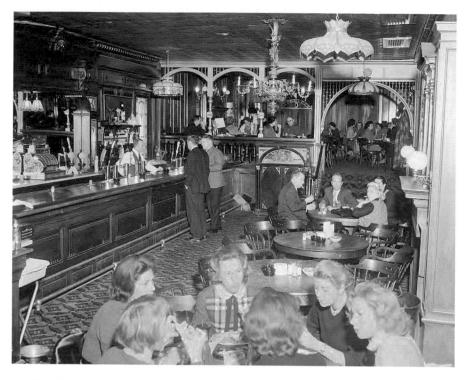

Red Dog Saloon, Atlanta, 1961. Although designed like earlier saloons, both men and women were welcome. *Photo by Tracy O'Neal. Special Collections and Archives, Georgia State University.*

polite drinking society—first in hotel restaurants with their husbands and boyfriends and then in cocktail lounges. If they were not comfortable at the bar, then tables in the establishment provided islands of social comfort for dating couples or groups of like-minded women.

Prohibition blind tigers (specifically barrel houses and juke joints) became underground test beds for blues and jazz musicians. White patrons ventured into clubs that featured black musicians, and music helped bridge the racial gap in public entertainment. Anecdotal evidence suggests that lasting racial desegregation in Atlanta bars was not seen until the late 1970s. Admittedly, our experience is that local bars often represent the communities in which they are based, but in mixed communities, we can witness people of all genders, religions, nationalities and ages peaceably enjoying a drink together. This was rarely the case pre-Prohibition.

## MODERN BREWERIES, DISTILLERIES AND WINERIES

Availability and price standardization, the main post-repeal market themes, are now challenged by attention to quality. As we venture into the current century, there is a renewed interest in the craftsmanship of brewing, distilling and wine making. Thanks to this interest, small breweries have sprung up all over the area, giving the public unprecedented variety. For the first time since state prohibition went into effect, Atlanta is home to a distillery. Old Fourth Distillery on Edgewood Avenue is producing vodka and plans to distill gin and whiskey for barrel aging in the near future.

Vodka bottles from the Old Fourth Distillery. *Ron Smith.*

A portion of the still at Old Fourth Distillery, which began local distribution in 2014. *Ron Smith.*

A street view of Atlanta's Old Fourth Distillery. *Ron Smith.*

Despite lingering temperance laws, Georgia has modernized portions of its state code. In 1995, House Bill 374 authorized the operation of brewpubs just in time for Atlanta's 1996 Summer Olympics. In July 2004, the 6 percent ABV cap on beer was lifted, allowing up to 14 percent beer. Four years later, Georgia expanded its winery direct shipping laws so that a larger quantity could be shipped to consumers from Georgia wineries and customers could participate in wine clubs. As of the writing of this book, proponents of Senate Bill 63, known as the "Beer Jobs Bill," seek similar limited direct-to-consumer sales by Georgia breweries. These small steps in modern prohibition repeal have allowed Atlanta to edge closer to the heyday of having its own adult beverage market in which consumers enjoy ample access to a variety of products, crafted within the community's breweries and distilleries, in a supportive city atmosphere.

Regardless of these commerce-driven victories, the state's beverage alcohol laws are still quite restrictive in comparison to the rest of the nation. The legislative lag is largely due to restrictive political attitudes toward alcohol (a direct descendent of prohibition) and business lobbying that protects those who profit from the current structure.

## THE FADED HISTORY OF ATLANTA LIBATIONS

As local craft distillers and brewers come online, it generates interest for the products, as well as the history of the particular beverages in the area. Sadly, the history of the city's saloons, distilleries and breweries is a subject examined by only a handful of historians and collectors.

The metro area's continual growth has left few historic buildings and little representation of historical artifacts. Industries perceived as vice are rarely well documented, which makes research more challenging. Further, Georgia's lengthy prohibition period clouded historical data pertaining to the beverage alcohol industry.

Throughout research for this book and *Atlanta Beer*, we have pondered several questions. What happened to all those decorative fixtures when state prohibition shut down the saloons? Why do so few photographs of Atlanta saloons exist? Were they destroyed by dry supporters? Did the social stigma of operating a saloon get so extreme that family members destroyed evidence of their businesses? What happened to the breweries' and distilleries' recipes?

Not all clues to this past are lost. Many individual artifacts are held in personal collections, are displayed occasionally at events or make surprising appearances in contemporary restaurants. Georgia State University's Phoenix Project is beginning to analyze the cultural remains unearthed during construction of the Metro Atlanta Rapid Transit Authority (MARTA) rail lines. From beer to patent medicine, artifacts of glass, metal and ceramic shed new light on Atlanta's historical imbibing.

## THE HUB OF THE SOUTH

In contrast to our visitor in 1880, a young businesswoman visiting Atlanta in 2015 would encounter a metropolitan area of over five million people.

Arriving by air at Hartsville-Jackson International Airport, she retrieves her bags and then walks to her hotel's courtesy shuttle. The repeated high-pitch whine of landing jet aircraft, the hustle and bustle of people and vehicles and the accompanying smell of jet fuel and car exhaust fades as the shuttle door closes and she is driven to her downtown hotel. Once inside, she may relax a moment at the bar and fortify herself with a cocktail, having traveled from the West Coast of the United States or possibly the opposite side of the

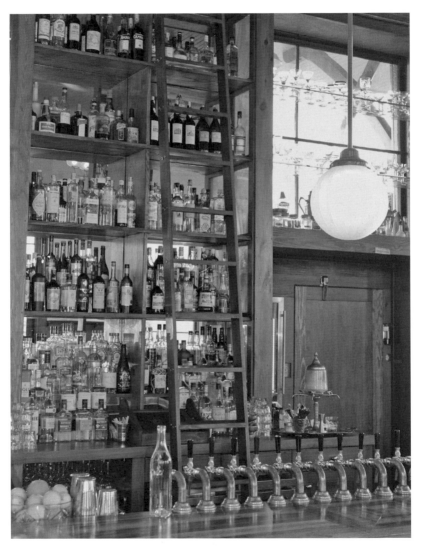

Atlanta's new Kimball House represents the modern American bar, a product of prohibition. *Ron Smith.*

planet. Union Station may be a distant memory, but the city of Atlanta is still a major transportation hub.

Once her daily business is completed, our visitor can wander through downtown Atlanta or venture into the metro area for dinner, drinks and entertainment. She might never walk in the same spot as the young man in the 1880s, as so much has changed. The city of that time is but a memory, rarely glimpsed in a building façade or an old photograph. The ghosts of Atlanta's prohibition legacy are more governmental than architectural.

The young woman may take a seat at a bar—perhaps the Luminary in Krog Street Market, the Porter in Little Five Points or the Kimball House in Decatur. The first location is named after an 1846 Atlanta newspaper and the latter for the famous downtown hotel. The drink she orders, whether beer, wine, whiskey or a carefully mixed cocktail, has survived nearly three hundred years of social upheaval and legislation starting with General Oglethorpe's prohibition against importing distilled spirits into the Colony of Georgia. The state and the city have clearly witnessed one of the longest and most ardent alcohol temperance and prohibition periods in America.

The fact that a highly educated professional female is working out in society and may be in charge of vast resources is a legacy of the suffrage movement, which was deeply tied to prohibition. Around her, people of many races, creeds, political orientations and worldviews interact freely. This open interaction, especially over alcohol, owes much of its success to the repeal of Prohibition, though we highly doubt anyone sitting at the bar thinks much about the alternative path history could have taken.

Many of the realities of prohibition have faded over time. Facts become muddled in the national mythology of the Roaring Twenties, bootleg gangsters, flappers and speakeasies. It is true that Al Capone and George Remus passed through the city's federal penitentiary, but Atlanta's gritty prohibition history more accurately ties to Decatur Street, anti-immigrant sentiment, racial tension, tiger kings, fire-and-brimstone temperance and trippers hauling white lightning.

# BIBLIOGRAPHY

## BOOKS/JOURNALS

*American Brewers' Review* 31, no. 1 (1917).

Ansley, J.J. *History of the Georgia Woman's Christian Temperance Union: From Its Organization 1883 to 1907.* Columbus, GA: Gilbert Printing Company, 1914.

*An Appeal to the Voters of Atlanta.* Pamphlet of the Committee of Twenty-Five. Atlanta, GA: Atlanta Constitution Job Print, 1885.

Baker, Ray. *Following the Color Line: An Account of Negro Citizenship in the American Democracy.* New York: Doubleday, Page & Co., 1908.

Ball, Mays. "Prohibition in Georgia: Its Failure to Prevent Drinking in Atlanta and Other Cities." *Putnam's Monthly and the Reader* 5 (October 1908–March 1909).

Cherrington, Ernest. *The Anti-Saloon League Yearbook 1917.* Westerville, OH: American Issue Press, 1917.

———. *The Anti-Saloon League Yearbook 1921.* Westerville, OH: American Issue Press, 1921.

———. *The Evolution of Prohibition in the United States of America.* Westerville, OH: American Issue Press, 1920.

Coker, Joe. *Liquor in the Land of the Lost Cause: Southern White Evangelicals and the Prohibition Movement.* Lexington: University Press of Kentucky, 2007.

*Collier's: The National Weekly* 76, no. 14 (1925).

"Connolly v. The City of Atlanta." *Southeastern Reporter* 4 (1888).

Dabney, Joseph. *Mountain Spirits*. Asheville, NC: Bright Mountain Books, 1974.

Davis, Marni. *Jews and Booze: Becoming American in the Age of Prohibition*. New York: New York University Press, 2012.

Donovan, Tristan. *Fizz: How Soda Shook Up the World*. Chicago: Chicago Review Press, 2014.

Dorsay, Allison. *To Build Our Lives Together: Community Formation in Black Atlanta, 1875–1906*. Athens: University of Georgia Press, 2004.

Ellis, John. *The Fruit of the Vine: Unfermented or Fermented—Which?* New York: National Temperance Society and Publication House, 1894.

Farrisee, Ann. *Georgia State Capitol—Historic American Buildings Survey No. GA-2109*. Washington, D.C.: Department of the Interior, 1997.

Fosdick, Raymond, and Albert Scott. *Toward Liquor Control*. New York: Harper & Brothers, 1933.

Fuller, Robert. *Religion and Wine: Cultural History of Wine Drinking in the United States*. Knoxville: University of Tennessee Press, 1996.

Garrett, Franklin. *Atlanta and Environs: A Chronicle of Its People and Events*. Vols. 1 and 2. Athens: University of Georgia Press, 1969.

Geer, William. "The Temperance Movement in Georgia in the Middle Period." Master's thesis, Emory University, 1936.

Godshalk, David. *Veiled Visions: The 1906 Atlanta Race Riot and the Reshaping of American Race Relations*. Chapel Hill: University of North Carolina Press, 2005.

Goodson, Steve. *Highbrows, Hillbillies & Hellfire: Public Entertainment in Atlanta, 1880–1930*. Athens: University of Georgia Press, 2002.

Hammell, George. *The Passing of the Saloon*. Cincinnati, OH: F.L. Rowe, Publishers, 1908.

Hamm, Richard. *Shaping the 18th Amendment: Temperance Reform, Legal Culture, and the Polity, 1880–1920*. Chapel Hill: University of North Carolina Press, 1995.

Hardesty, Nancy. "The Best Temperance Organization in the Land: Southern Methodists and the W.C.T.U. in Georgia." *Methodist History Journal* 28, no. 3 (April 1990).

Herringshaw, Thomas. *The Biographical Review of Prominent Men and Women of the Day*. Washington, D.C.: A.B. Gehman & Co., 1888.

Hertzberg, Steven. *Strangers within the Gate City: The Jews of Atlanta, 1845–1915*. Philadelphia: Jewish Publication Society of America, 1978.

Hunter, Tera. *To 'Joy My Freedom: Southern Black Women's Lives and Labors after the Civil War*. Cambridge, MA: Harvard University Press, 1997.

*Index to the Executive Documents of the House of Representatives for the Second Session of the Forty-Sixth Congress, 1879–'80*. Vol. 24. Washington, D.C.: U.S. Government Printing Office, 1880.

Jewell, Joseph. *Race, Social Reform, and the Making of a Middle Class: The American Missionary Association and Black Atlanta, 1870–1900.* Lanham, MD: Rowman & Littlefield, 2007.

*Journal*, May 19, 1913. [Reprinted in *Atlanta and Environs*, vol. II.]

Jurkiewicz, Carole, and Murphy Painter. *Social and Economic Control of Alcohol: The 21$^{st}$ Amendment in the 21$^{st}$ Century.* Boca Raton, FL: CRC Press, 2008.

Knight, Lucian. *A Standard History of Georgia and Georgians.* New York: Lewis Publishing Company, 1917.

Kuhn, Clifford, Harlon Joyce and Bernard West. *Living Atlanta: An Oral History of the City, 1914–1948.* Athens: University of Georgia Press, 1990.

*Liberty Under Law and Selected Supreme Court Opinions.* Vol. 8. *Samuels v. McCurdy.* Athens: Ohio University Press, 2004.

Martin, Thomas. *Atlanta and Its Builders: A Comprehensive History of the Gate City of the South.* Atlanta: Century Memorial Publishing Company, 1902.

Mason, Herman, Jr. *African-American Entertainment in Atlanta.* Charleston, SC: Arcadia Publishing, 1998.

*Men of the South: A Work for the Newspaper Reference Library.* New Orleans, LA: Southern Biographical Association, 1922.

Miller, Nathan. *New World Coming: The 1920s and the Making of Modern America.* Cambridge, MA: De Capo Press, 2003.

Minnix, Kathleen. *Laughter in the Amen Corner: The Life of Evangelist Sam Jones.* Athens: University of Georgia Press, 1993.

Moore, Hammond. "The Negro and Prohibition in Atlanta, 1885–1887." *South Atlantic Quarterly* 69, no. 1 (Winter 1970).

Morgan, Michael. *Over-the-Rhine: When Beer was King.* Charleston, SC: The History Press, 2010.

Murchison, Kenneth. *Federal Criminal Law Doctrines: The Forgotten Influence of National Prohibition. Cooley v. The State.* Durham, NC: Duke University Press, 1994.

Murdock, Catherine. *Domesticating Drink: Women, Men, and Alcohol in America, 1870–1940.* Baltimore, MD: Johns Hopkins University Press, 1998.

Newman, Harvey, and Glenda Crunk. "Religious Leaders in the Aftermath of Atlanta's 1906 Race Riot." *Georgia Historical Quarterly* 92, no. 4 (Winter 2008).

Oakley, Giles. *The Devil's Music: A History of the Blues.* Cambridge, MA: Da Capo Press, 1997.

Odegard, Peter. *Pressure Politics: The Story of the Anti-Saloon League.* New York: Octagon Books, 1966.

O'Neal, Jim, and Amy van Singel. *The Voice of the Blues: Classic Interviews from Living Blues Magazine.* New York: Routledge, 2002.

Pruett, Jed. *The Contested Gate City: Southern Progressivism's Roots in Atlanta's Local Politics, 1885–1889*. Knoxville: University of Tennessee Honors Thesis Project, 2011.

Rabby, Glenda. "The Woman's Christian Temperance Union in Georgia, 1883–1918." Master's thesis, Florida State University–Tallahassee, 1978.

Ruth, David E. "The Georgia Prohibition Act of 1907: Its Proponents and Their Arguments." Master's thesis, Emory University, 1984.

———. *Inventing the Public Enemy: The Gangster in American Culture, 1918–1934*. Chicago: University of Chicago Press, 1996.

*Saturday Evening Post* 180, no. 21 (1907).

Sawyer, Gordon. *Northeast Georgia: A History*. Charleston, SC: Arcadia Publishing, 2001.

Scomp, Henry. *King Alcohol in the Realm of King Cotton*. Chicago: Blakely Print Company, 1888.

Small, Sam. *Pleas for Prohibition*. Atlanta: printed for the author, 1890.

Smith, Ron, and Mary Boyle. *Atlanta Beer: A Heady History of Brewing in the Hub of the South*. Charleston, SC: The History Press, 2013.

*Sons of Temperance Offering for 1850*. New York: Nafis & Cornish, 1850.

Stevens, George, and John Graham. *Reports of Cases decided in the Supreme Court of the State of Georgia…March and October, 1921*. Vol. 152. Columbia, MO: E.W. Stephens Publishing, 1922.

Supreme Court of Georgia. *Reports of Cases in Law and Equity…March and October Terms, 1887*. Vol. 79. Atlanta: Franklin Publishing House, 1889.

Tankersley, Allen. "Basil Hallam Overby: Champion of Prohibition in Antebellum Georgia." *Georgia Historical Quarterly* 31 (1947).

Thompson, H. Paul, Jr. *A Most Stirring and Significant Episode: Religion and the Rise and Fall of Prohibition in Black Atlanta, 1865–1887*. DeKalb: Northern Illinois University Press, 2013.

Thompson, Neal. *Driving with the Devil: Southern Moonshine, Detroit Wheels, and the Birth of NASCAR*. New York: Three Rivers Press, 2006.

Van Buren, Jarvis. *The Scuppernong Grape, Its History and Mode of Cultivation*. Memphis, TN: Goodwyn & Company, 1871.

Veach, Michael. *Kentucky Bourbon Whiskey: An American Heritage*. Lexington: University Press of Kentucky, 2013.

Wahl, Robert, and Arnold Wahl. *American Brewers Review* 12 (June/July 1898–99).

*World Almanac and Encyclopedia, 1908*. New York: Press Publishing Company, 1908.

*Year Book of the United States Brewers' Association for 1910*. New York: United States Brewers' Association, 1910.

## MUSIC / POETRY

Brown, Tommy. "Fats Hardy Tardy." *Classic Tommy Brown.* http://www.TommyBrownBlues.com.

Echoes of Zion. "Atlanta's Tragic Monday." *The Best of Classic Gospel.* Stardust Records, 2007.

Sloan, Dave. "Prohibition Victory in Atlanta, GA." *Fogy Days, and Now; or, The World Has Changed.* Atlanta: Foote & Davies, Printers, 1891.

## NEWSPAPERS SEARCHED IN ELECTRONIC FORMAT

*Ames Daily Tribune,* 1933.
*Atlanta Constitution,* 1868–2001.
*Atlanta Journal,* 1883–2001.
*Atlanta Journal-Constitution,* 2001–Current.
*Boston Herald,* 1924.
*Daily Constitution,* 1880.
*Freeport Journal-Standard,* 1933.
*New York Times,* 1917.
*Sunday Constitution,* "Magazine," 1922.
*Sunny South,* 1875–1907.
*Thompsonville Times-Enterprise,* 1933–34
*Washington Times,* 1917.

## INTERVIEWS/PERSONAL DISCUSSIONS WITH AUTHORS (UNLESS OTHER COMMUNICATION NOTED)

Bearden, Dwight, distiller. Dawsonville Moonshine Distillery, December 2014.

Butler, Howard Colonel, ret. Recounted memories of segregation, December 2014.

Jones, Ken, Atlanta breweriana expert. E-mail communication, November 2014.

## VISUAL MEDIA

Ward, Geoffrey. *Prohibition*. DVD. Directed by Ken Burns and Lynn Novick. Hollywood, CA: Prohibition Film Project, 2011.

## WEBSITES

Alcoholic Beverage Control Before Repeal. http://scholarship.law.duke.edu/cgi/viewcontent.cgi?article=2040&context=lcp (accessed November 27, 2014).

Anti-Saloon League of America. http://www.westervillelibrary.org/antisaloon (accessed May 8, 2014).

Atlanta City Directories, 1878–1922. Digital Library of Georgia. http://dlg.galileo.usg.edu/cgi-bin/meta.cgi (accessed May 10, 2014).

Atlanta Time Machine. www.atlantatimemachine.com (accessed May 10, 2014).

CPI Inflation Calculator. Bureau of Labor Statistics. http://www.bls.gov/data/inflation_calculator.htm (accessed February 19, 2015).

*Emory* magazine. "Moonshine in the City." http://www.emory.edu/EMORY_MAGAZINE/spring2004/precis_moonshine.html (accessed November 10, 2014).

Fold 3. http://www.fold3.com (accessed February–December 2014).

Georgia Encyclopedia. http://www.georgiaencyclopedia.org/articles/history-archaeology/civil-war-atlanta-home-front (accessed October 2, 2014).

History of Taxation in the U.S. Encyclopedia of Earth. http://www.eoearth.org/view/article/153529 (accessed November 6, 2014).

Inflation Calculator. http://www.westegg.com/inflation/ (accessed February 19, 2015).

Justia U.S. Law. 2010 Georgia Code Title 3—Alcoholic Beverages. Chapter 3, "Regulation of Alcoholic Beverages." http://law.justia.com/codes/georgia/2010/title-3/chapter-3/article-1/3-3-1 (accessed February 22, 2015).

New Era Beer. http://www.mrbottles.com/newsDetail.asp?ID=2 (accessed October 4, 2014).

Ohio ASL. http://www.ohiohistorycentral.org/w/Ohio_Anti-Saloon_League (accessed May 8, 2014).

Prohibition Party. http://www.prohibitionparty.org (accessed May 8, 2014).

R.M. Rose Company. https://www.facebook.com/rmrose/info?tab=page_info (accessed October 28, 2014).

Sanborn Fire Insurance Maps for Atlanta, 1886–1922. Digital Library of Georgia. http://dlg.galileo.usg.edu/sanborn (accessed February–August 2014).

Unique History of Madeira Wine. http://www.juniata.edu/services/jcpress/voices/pdf/2008/Madeira%20-%20James%20Tuten%20-%20Juniata%20Voices.pdf (accessed February 16, 2014).

U.S. Department of Justice—Historical Badges. https://www.atf.gov/press/releases/2008/12/122908-historical-badges-tell-story.html (accessed December 25, 2014).

WCTU. http://www.wctu.org/earlyhistory.html (accessed September 3, 2014).

Wikipedia. "Tabernacle." en.wikipedia.org/wiki/The_Tabernacle (accessed March 6, 2014).

William Upshaw. http://www.prohibitionists.org/history/William_Upshaw_Bio.htm (accessed September 29, 2014).

# Index

## T

Talley, Herbert W. 119
three-tiered system 151, 152
tied house 21, 46, 92, 151
tripper 126, 131, 134
Turn Verein 86, 108
Twenty-first Amendment 145, 151
two-wine theory 84

## U

United States Brewers' Association 38,
    62, 86

## V

Volstead Act 113, 115, 144

## W

Washingtonian Temperance Society 28
Western and Atlantic Railroad 11
Wheeler, Wayne 67
whiskey
  Agaric 50
  corn 12, 48, 102, 122
  medicinal 31, 74
  rectified 19
  white 18, 122, 131
whiskey war 119
Whitehall Tavern 11
White Hops 92, 93
white lightning 128
Willard, Frances 33, 35, 141
wine 22, 38, 43, 84, 139
Woman's Christian Temperance Union
    (WCTU)
  Georgia 34, 36, 38, 47, 54, 55, 67, 146
  national 33, 99, 107, 141, 153
Women's Organization for National
    Prohibition Reform (WONPR)
    142
women's suffrage 30, 141, 153
World War I 108, 141
Wright, Seaborn 62, 67, 126

# ABOUT THE AUTHORS

## RONALD J. SMITH

In addition to co-authoring *Atlanta Beer: A Heady History of Brewing in the Hub of the South*, Ron has hosted beer and food pairing dinners and beer education sessions. He was a featured speaker for the Georgia Center for the Book in 2014. Together with Mary Boyle, he developed the Malts and Vaults tour at Atlanta's Historic Oakland Cemetery. An obsessive researcher, Ron is deeply interested in the history of beverage alcohol in the American South and its role in society. He is a member of the American Breweriana Association and the Southern Historical Association. When not pursuing history or libations, Ron is an environmental consultant and does some volunteer work with Oakland Cemetery.

*Photo by Mary Boyle.*

# MARY O. BOYLE

A curious researcher and hawk-eyed editor, Mary manages multiple websites for her own businesses and the books written with Ron. Her interest is in making history approachable for a broad audience. Writing *Atlanta Beer* inspired her to design a line of libation-focused pieces for her handcrafted jewelry line. Mary exercises her creativity in a variety of writing projects, including web copy, résumés and nonfiction. She is also committed to supporting Oakland Cemetery as one of Atlanta's historic treasures.